Conspiracy Theories
Mystery and Secrecy

Publisher and Creative Director: Nick Wells
Commissioning Editor: Polly Prior
Senior Project Editor: Catherine Taylor
Art Director: Mike Spender
Layout Design: Jane Ashley
Digital Design and Production: Chris Herbert
Copy Editor: Anna Groves
Proofreader: Dawn Laker
Indexer: Helen Snaith

Special thanks to: Taylor Bentley

FLAME TREE PUBLISHING
6 Melbray Mews
Fulham, London SW6 3NS
United Kingdom

www.flametreepublishing.com

First published 2018

18 20 22 21 19
1 3 5 7 9 10 8 6 4 2

Image Credits: Courtesy of **Bridgeman** and © the following: 81 Private Collection/Look and Learn. Courtesy of **Getty Images** and © the following: 3 & 142 French School; 4 & 36 Popperfoto; 6 & 155 SuperStock; 35 John Wessels/AFP; 38 Mauricio Lima/AFP; 38–39 Roger Ressmeyer/Corbis Documentary/VCG; 54 Spaces Images/Blend Images; 57 Ulrich Baumgarten; 60 Paul Turner/Hulton Archive; 69 Chad Buchanan/Getty Images Europe; 70 Rykoff Collection/Corbis Historical; 73 VCG Wilson/Corbis Historical; 74, 85 Universal History Archive; 88 Alexander Memenov/AFP; 89 Natasja Weitsz; 90 Bryn Colton/Hulton Archive; 91 Roy Letkey/AFP; 93 Visual China Group; 94 Ted Thai/The LIFE Picture Collection; 110–111 Fine Art Images/Heritage Images/Hulton Fine Art Collection; 112 Prisma/PHAS/Universal Images Group; 114 Ann Ronan Pictures/Print Collector/Hulton Archive; 118, 123, 148, 176 Bettmann; 127 De Agostini Picture Library; 128, 130 Photo12/Universal Images Group; 129, 186 Hulton Archive; 133, 134 Fototeca Gilardi/Fototeca Storica Nazionale/Hulton Archive; 136 Mansell/The LIFE Picture Collection; 137 The Print Collector/Hulton Archive; 141 G.DAGLI ORTI/De Agostini Picture Library; 146 The LIFE Picture Collection; 147 James Gass/EyeEm; 152 Rolls Press/Popperfoto; 153 Frank Hurley/New York Daily News Archive; 157 Tim Graham Photo Library; 162 Hulton-Deutsch Collection/Corbis Historical; 165 Corbis Historical; 171 Aamir Qureshi/AFP; 173 Hulton Archive/Archive Photos; 174 Stefano Bianchetti/Corbis Historical; 177 Michael Ochs Archives; 178 Time Life Pictures/DMI/The LIFE Picture Collection; 179 Clarence Davis/NY Daily News; 180 Steve Granitz/WireImage; 181 NY Daily News; 184 Leo Mason/Popperfoto; 185 Independent Newspapers Ireland/Independent News And Media/Hulton Archive; 188 Stefano Bianchetti/Corbis Historical. Courtesy of and © **Mary Evans Picture Library**: 77, 116, 117, 145, 154. Courtesy of **United States Department of Agriculture**: 30. Courtesy of **Shutterstock.com** and © the following: 1 & 150, 28, 163 Everett Historical; 7 aapsky; 9 & 82 Roschetzky Photography; 10 Standret; 14 kojihirano; 15 SipaPhoto; 16 Howard Pimborough; 19 emperorcosar; 23 Michael Dorogovich; 24 Styve Reineck; 26 lavizzara; 31 Ezume Images; 40 stockphoto mania; 41 miker; 43 sirtravelalot; 44 aapsky; 49 ded pixto; 52 Africa Studio; 53 Peshkova; 58 shipfactory; 59 Kiattisak Lamchan; 60 Vacclav; 62 Mariusz Matuszewski; 64, 66 Nosyrevy; 71 Joseph August; 78 Mark Van Scyoc; 84 JimboMcKimbo; 88–89 Baturina Yuliya; 98 Evan El-Amin; 101 Rob Crandall; 102 Anna Ewa Bieniek; 104 nixki; 107 Francisco J. Ramos Gallego; 108 Robert CHG; 110 Eduardo Rivero; 126 Anton_Ivanov; 140–141 Tom Grundy; 142–143 Reinhold Leitner; 166 photosounds; 167 Lenscap Photography; 168 Dan Kosmayer; 170 Carolina K. Smith MD; 182 NPFire; 186–187 Scisetti Alfio; back cover Bernhard Staehli. © **Rex/Shutterstock** and the following: 8 Alan Davidson; 17 Sipa Press; 20 The Art Archive; 32, 34 Cultura; 63 Glasshouse Images; 65 Design Pics Inc; 75 New World/Kobal; 76 TODAY; 86, 121, 156 Shutterstock; 97 Janine Wiedel; 100 Granger; 105 British Library/Robana; 122 Christies/Bournemouth News; 125 imageBROKER; 138 Gianni Dagli Orti; 140 Jonathan Hordle; 158 Associated Newspapers; 161 ANDY PARADISE; 164 KeystoneUSA-ZUMA; 169 David Magnus; 183 Evening News; 187 Universal History Archive. © **Michael Kleiman, US Air Force**/Wikimedia Commons: 25. © **Mike Herbst**/Wikimedia Commons/CC-BY-SA-2.0: 50.

ISBN: 978-1-78664-797-9

Printed in Hong Kong

Conspiracy Theories
Mystery and Secrecy

Michael Robinson

FLAME TREE
PUBLISHING

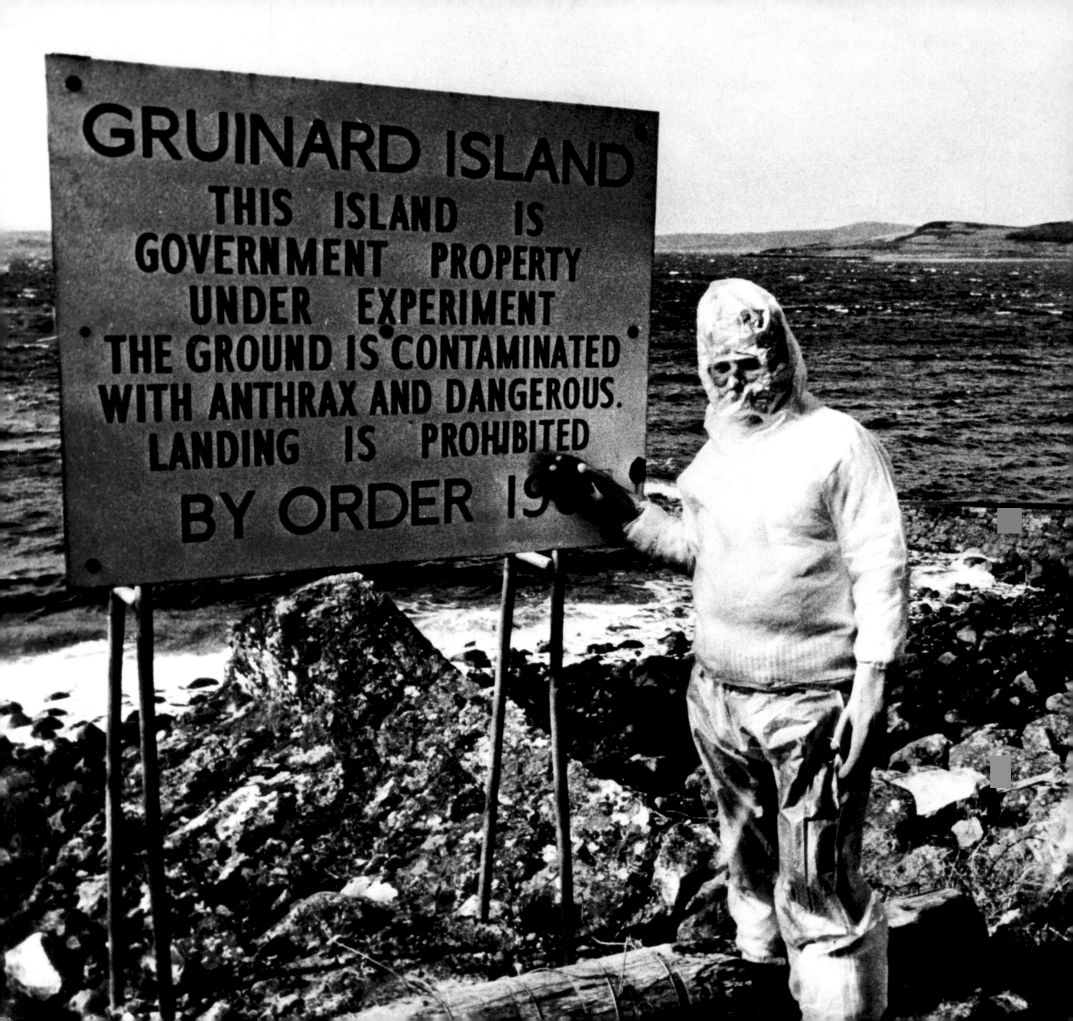

Contents

Introduction

The *Oxford English Dictionary* defines 'conspiracy' as 'a secret plan by a group to do something unlawful or harmful'. We think of conspiracies as being orchestrated by governments, corporations, the media and secret organizations, and the theorists as those who question the validity of information given by them. We live in an era of 'fake' news and 'alternative' facts that can be and are investigated online via the internet, but some people believe that its agencies are complicit in the conspiracies and cover them up with misinformation.

Behind all conspiracy theories is the idea that we are controlled by design rather than arbitrary causes. Thus, according to theorists, nothing happens by accident, appearances are deceptive, and the theory's constituent parts are linked – a kind of puzzle or riddle that has to be solved by the theorist and his disciples. Clearly, conspiracy theories and secrecy are tangibly linked. Some theorists cite secret organizations such as the Illuminati who, in the New World Order, have almost unlimited power. Others cite known groups but with secret agendas, such as the Bilderberg Group.

A Climate of Fear

We can probably begin thinking about the modern phenomenon of conspiracy theories as emerging in the post-Second World War era, when, for various reasons to do with safety and security during the Cold War, it was necessary to conceal facts from the general public. In many ways, the fear of 'Reds under the Beds' was exploited in the West, as a propaganda tool by Western governments in the face of the alleged threat from the Soviet Union. Such machinations were orchestrated by, among others, Senator Joseph McCarthy (1908–57) and the Director of the FBI, J. Edgar Hoover (1895–1972). With the fall of McCarthyism in the mid-1950s

and his exposure as a fearmonger, many people began to lose faith in the government for honesty and transparency.

In a now-famous essay written in 1964, the Pulitzer Prize-winning writer Richard Hofstadter (1916–70) suggested that 'heated exaggeration, suspiciousness, and conspiratorial fantasy' were contributing factors to what he called the 'paranoid style in American politics', one that had a 'greater affinity for bad causes than good'. According to him, the 'paranoid style' had always been a factor in American life, but until the 1960s had been confined

to minority movements. His ideas were possibly developed in the aftermath of the Kennedy assassination in 1963, when conspiracy theories were proliferating about the President's death.

A Culture of Conspiracy

Today, the JFK theories are no longer those of a minority; according to some polls, two thirds of US citizens believe the assassination to have been conspiratorial. What happened in those intervening years to change public opinion? We can attribute this, in part at least, to the plethora of books on the subject of conspiracy theories, populist publications with titles such as *Conspiracy! 49 Reasons to Doubt, 50 Reasons to Believe* (2012) and *100 Things They Don't Want You to Know* (2015) that continue to nourish the appetites of the masses. There are of course countless documentaries, such as 'Cowspiracy' referred to later in this book, and blockbuster films such as *The Da Vinci Code* (2006) that have popularized conspiracy theories. Many of these theories are fed by paranoia, but the exponential rise in conspiracy theories has much to do with society's attitude to the new millennium, or Millennialism.

Michael Barkun (b. 1938), a leading academic on the subject of the culture of conspiracy in America, suggests that Millennialism – the belief that societal changes occur every one thousand years – is often linked to conspiracy theories in a relationship that is 'mutually reinforcing'. We think of Millennialism as part of Christian faith and culture, and that Christian Millennialists may view the world's leaders as the personification of the Biblical Antichrist. Similarly, secular Millennialists, such as Marxists, may see those same leaders as conspirators in a capitalist plot. In these examples, both share the orthodoxy of their respective writings, The Bible and *Das Kapital*, to promulgate their beliefs. According to Barkun, the boundaries between theological and secular thought have now become blurred in what he calls 'improvizational Millennialism', in which new forms of belief systems create a more flexible approach to conspiracies.

A New Age of Information

The first and most notable conspiracy theory to emerge in the new millennium surrounded the events of 9/11, which is discussed later in the book. It is mentioned here because the event seemed to mark a watershed in conspiracy theory, one in which information provided by the state through various media outlets was being heavily scrutinized using the internet, most particularly on blogging sites. Conspiracy theorists are thus no longer a small coterie on the fringe: they can now permeate all of society, which can in turn offer feedback and comment on the various discourses. In a

nutshell, fringe has become mainstream, where everyone has an opinion. You, the reader, may not be, or consider yourself a conspiracy theorist and yet here you are engaging in the topic right now. You have begun with a simple premise, questioning what you think you know about a subject. At the moment, we are going through a phase of fashionable conspiracism in which most people have an opinion. Some people limit their involvement to an acknowledgement of the theory, others participate and discuss the issues, while the minority may make it a crusade to expose the truth.

Conspiring Together

Broadly speaking, conspiracy theories can be classified into three groups: those surrounding an event such as the JFK assassination; those that are systemic, as in the machinations of the oil industry, or of an organization such as the Masons; and finally, those that Barkun refers to as 'Super-conspiracies', in which multiple conspiracies are enmeshed and controlled by a powerful evil force. A notable example of this would be the so-called 'Reptilian Elite' as promulgated by the prominent conspiracy theorist David Icke (b. 1952). Conspiracy theories have moved in tandem with the news, offering plausible explanations for tragedies and unexplained events, an example being the death of Diana, Princess of Wales. One theory states that she was murdered by the British Royal Family, which, as well as being a conspiratorial event, may well be within the realms of a 'Super-conspiracy', since it is alleged that the Queen is part of the Reptilian Elite. Despite the sensationalism of the theory that the Royal Family murdered her, and its subsequent rebuttal by the authorities, the accusations often reflect society's fears, their mistrust of government and, in more general terms, the Establishment.

The writer Jesse Walker (b. 1970) identifies another way of grouping conspiracies: the 'Enemy Outside' (for theories concerning those conspiring against a community from the outside); the 'Enemy Within' (its domestic equivalent); the 'Enemy Above' (powerful people manipulating events for

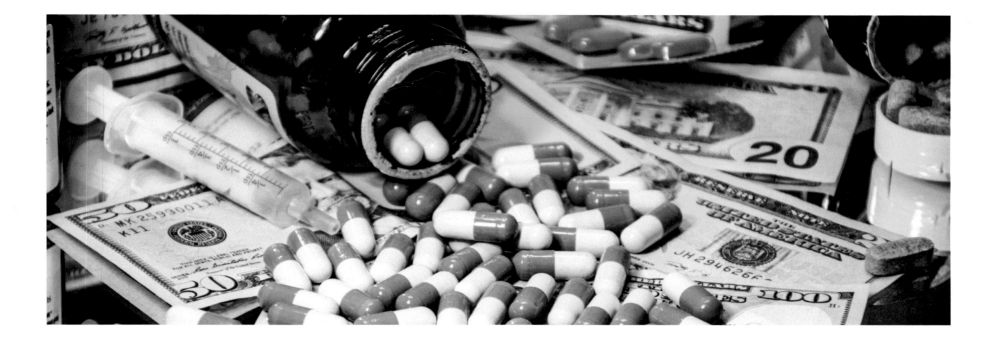

their own gain); and the 'Enemy Below' (comprising the lower orders who seek to overturn the upper echelons of society). What links these groupings is the sense of malevolence by the alleged perpetrators in a conspiracy theory, and since it cannot usually be disproven, the theory is a matter of faith more than actual proof of its existence.

Another type of conspiracy theory involves revisionist history, in which theorists question the validity of traditional narratives. An example would be the Shakespeare Question, as to whether a glove-maker's son from rural Stratford-upon-Avon could possibly have written sublime sonnets and plays that deal with courtly life. Other obvious examples of revisionism include Holocaust denial and Biblical history, both of which have been the subject of numerous conspiracy theories over the years.

Doubting the Doubters

Not everyone subscribes to conspiracy theories, believing theorists to be either deranged or simply anti-Establishment. It is true that conspiracy believers often come from disenfranchised social minorities, the poorly educated and low earners. Psychologists are beginning to understand the factors that attract people to these theories, which are said to help people reconcile events that are out of their control. Professor of Psychology at the University of Kent, Karen Douglas, who specializes in conspiracy theories, suggests that, in general, people prefer 'big explanations for big events' when a more simple and plausible explanation is inadequate, or where certain 'facts' contradict each other. What is noticeable today is the number of different conspiracy theories for the same event that seem to live harmoniously on the internet. Douglas cites the example of Osama bin Laden, who many theorists believe died before the stage-managed killing in Pakistan, while others believe him to still be alive. She suggests that the variation is dependent on the individual's psychological needs.

Delving In

This book examines many of the most popular (and some of the lesser-known) conspiracy theories and mysteries that continue to fascinate us. Although conspiracy theories have been around for centuries, they appear to have been a notable phenomenon of the twentieth century and continue to intrigue unabated today.

Outer Space

One of the big questions for us since the last century has been: 'Are we alone?' Incredibly, Lucien of Samosata (*c.*125–185 AD) was asking that same question in the second century, in his book *A True Story*, generally considered the first work of science fiction. Our obsession with space travel and aliens has grown with the plethora of science fiction books and films, and of course with actual space travel, which began in the 1960s.

Today, we are starting to think more broadly about extraterrestrial life; the science of astrobiology studies 'extremophiles', newly discovered organisms that are capable of living in extreme conditions. The hypothesis is that human life started as an organism on Earth, when the planet was inhospitable for complex organisms to survive, and evolved.

UFOs

Our continual search for, and obsession with, extraterrestrial beings has been a human preoccupation since *The War of the Worlds*, a late nineteenth-century science fiction novel by H.G. Wells (1866–1946). It was Wells who first gave form to alien beings, or 'Greys', described as similar to humans but proportionately different in their body shape, grey-skinned and devoid of certain external organs such as a nose and ears. Since that time, there have been numerous 'sightings' to support these images, most notably by Betty (1919–2004) and Barney (1922–69) Hill, who claimed to have been abducted in New Hampshire during September 1961. There have been several other 'sightings' and 'abductions', fuelled no doubt by the range of television and film productions since the latter half of the twentieth century.

Left: Aliens: just figments of our imagination, or theoretically possible?

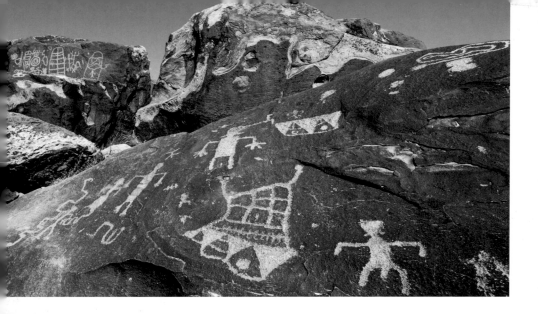

Above: Could these anthropomorphic figures of 'aliens' and 'spaceships' found in remote Utah, USA, be evidence that extraterrestrials visited our planet in ancient times?

Ancient Astronaut Theory

The Swiss writer Erich von Däniken (b. 1935), in his bestselling book *Chariots of the Gods*, published in 1968, was the first to hypothesize that extraterrestrial beings inhabited the Earth in ancient times, made contact with humans and taught them the skills necessary to build temples, pyramids and other sophisticated constructions in the development of a modern culture. His hypothesis is based on evidence found at various sites that will be explored in this book, such as the Pyramids of Egypt and the Mayan civilization in Central America. A common symbol in ancient civilizations is the serpent (sometimes depicted as a dragon) that was the giver of knowledge. Theorists believe that these ancient depictions were in fact a form of spacecraft that could breathe fire.

Roswell and Area 51

In 1947, a military weather balloon crashed at Roswell, New Mexico. Despite the local newspaper reporting that the military had discovered a crashed 'flying saucer', the story waned in the public mind until 30 years later, when a small team of UFO researchers began interviewing some

Right: The entrance to Groom Lake, also known as Area 51.

WARNING

Restricted Area

It is unlawful to enter this area without permission of the Installation Commander.
Sec. 21, Internal Security Act of 1950; 50 U.S.C. 797

While on this Installation all personnel and the property under their control are subject to search.

Use of deadly force authorized.

WARNING!
NO TRESPASSING
AUTHORITY N.R.S. 207-200
MAXIMUM PUNISHMENT: $1000 FINE
SIX MONTHS IMPRISONMENT
OR BOTH
STRICTLY ENFORCED

PHOTOGRAPHY
OF THIS AREA
IS PROHIBITED
18 USC 795

WARNING

MILITARY INSTALLATION

IT IS UNLAWFUL TO ENTER THIS INSTALLATION WITHOUT
THE WRITTEN PERMISSION OF THE INSTALLATION COMMANDER.

INSTALLATION COMMANDER
AUTHORITY: Internal Security Act, 50
U.S.C. 797
PUNISHMENT: Up to one year imprisonment
and $5,000. fine.

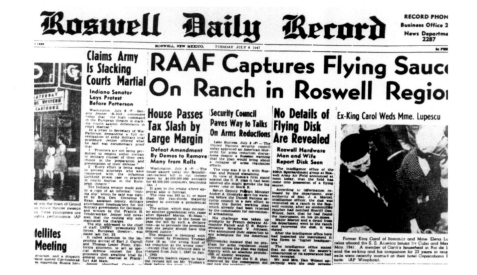

Above: Fake news, 1947 style, or is the truth really out there?

of the residents of the town who had witnessed events in 1947. Their conclusion was that at least one alien craft had crashed, alien bodies had been removed and the authorities were covering it up. The prevailing mood of the 1980s concerning cover-ups and conspiracies almost certainly fuelled this interest, and several books were written and documentaries made about the Roswell incident. In 1995, a film was released for public viewing showing the alleged footage of an alien autopsy carried out at Roswell. This was later confirmed as a hoax, although the filmmaker, Ray Santilli (b. 1958), claimed it was a reconstruction of the original film which had been 'lost'.

Another location for UFO sightings is Area 51, a top-secret and closely guarded military base in the Nevada Desert. While it is certain that many prototype aircraft and missiles are tested at this facility, its remote location and strange phenomenal sighting have led many to believe this is the place where any recovered alien spacecraft and its crew would be brought. A number of sightings have also been made in Britain, most notably in 1974 at the Berwyn Mountains in Wales, which newspaper reporters wittily entitled the 'Roswales Incident'.

Left: The Berwyn Range, North Wales, site of the alleged Roswales incident.

The Pyramids

A commonly held belief is that extraterrestrials created many of the ancient sites such as the Pyramids in Egypt and Stonehenge in England, since man had neither the technological skills nor the vision to have built them. Erich von Däniken has suggested as part of his ancient astronaut theory that humans learned the skills from these alien beings and in turn worshipped them as gods. Despite being widely discredited by scientists, the theory still has an enduring appeal, as many questions remain unanswered about the origins of some sites.

The Great Pyramid is supposed to have been built within a 20-year period, according to the inscriptions written inside its walls. It was completed in the year 2560 BC. At 146 metres (480 feet) high and built from two-and-a-half million blocks of stone weighing an average of two tons, it was the tallest building in the world until the thirteenth century. Even if it took as long as 20 years to complete, and assuming work continued around the clock, the construction would have involved moving, lifting and erecting 340 of these two-ton stones every day, using ancient technology!

Lost Cosmonauts

While it is generally accepted that the Russian cosmonaut Yuri Gagarin (1934–68) was, in 1961, the first man in outer space, conspiracy theorists have mooted that, prior to this inaugural flight, at least two other cosmonauts died in earlier attempts. In what was then a very secret Communist society, such information would have been suppressed, particularly as there was a so-called 'space-race' between the Soviet Union and the United States at the time. Allegedly, one of the early flights went off course and the cosmonaut was detained by the Chinese government, another secretive nation then under the control of Mao Zedong (1893–1976).

Right: Did the Ancient Egyptians have extraterrestrial help with building the pyramids?

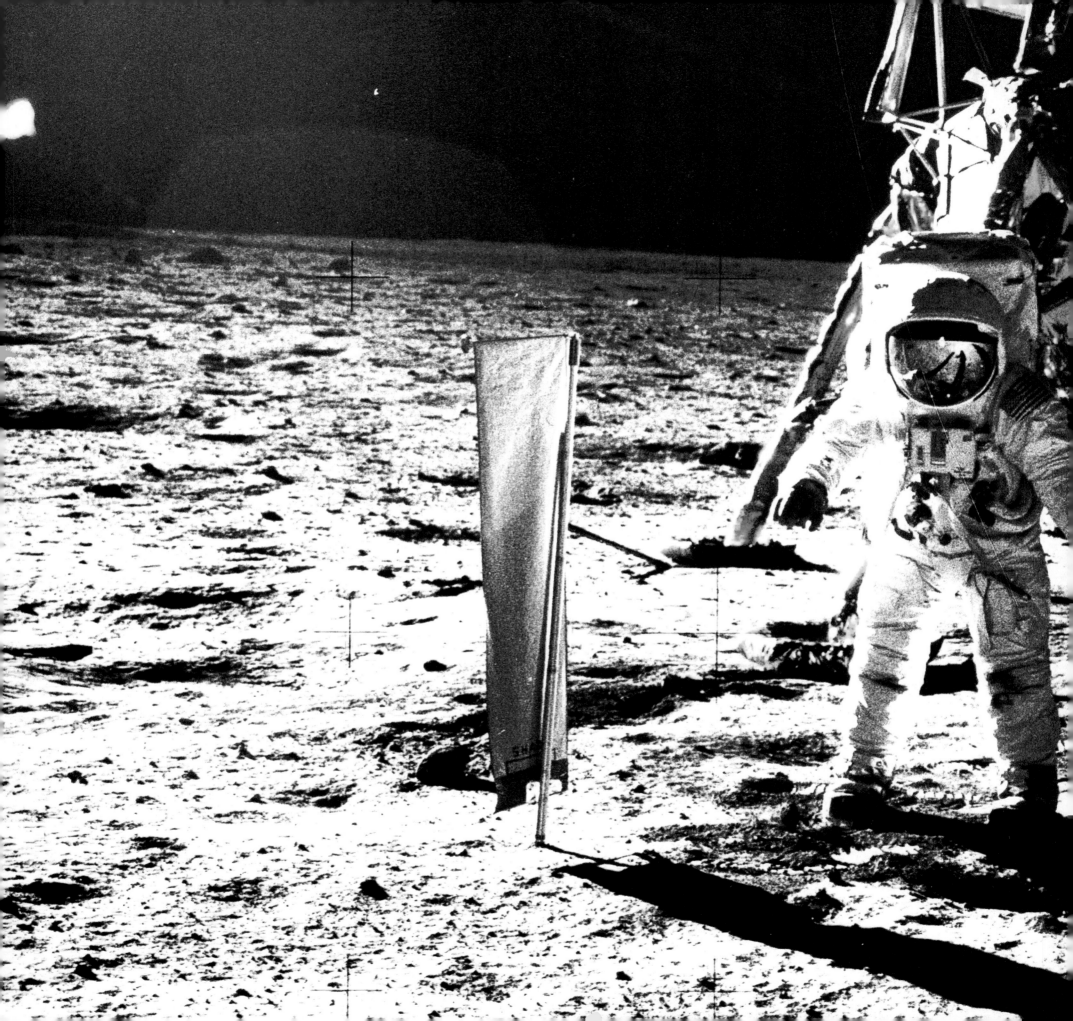

Since the collapse of the Soviet Union in the early 1990s, at least one cosmonaut is known to have died during training, which was covered up by the government, although there has been no evidence to support the lost cosmonauts theory. Conspiracy theorists also began speculating after the sudden death of Yuri Gagarin in 1968 during a training flight, wondering if this too was part of a cover-up.

Moon Landings

A number of people have, since the first Moon mission in 1969, alleged that NASA had faked the landings. One of the most influential books on the subject was by Bill Kaysing (1922–2005), who, in *We Never Went to the Moon: America's Thirty Billion Dollar Swindle* (1976), questioned the authenticity of the images beamed back to Earth. For example, why would the American flag be fluttering when there was no atmosphere on the Moon's surface? Aside from other optical anomalies, why were there no blast marks when the landing craft descended? Kaysing, himself a technical journalist in the aerospace industry, alleged that NASA did not have the technology to undertake these missions and also questioned how the craft survived the radiation of the Van Allen belt.

At a time when it seemed critical to have won the space race against the Soviet Union, he alleges that the whole mission was filmed on Earth at a secret location, possibly Area 51 in the Nevada Desert. Despite NASA's vehement denial of a hoax and the support of many technical experts, several documentaries have been made to support the conspiracy theory that the landings were faked. Interestingly, only five per cent of Americans believe them to be faked, while citizens of other countries around the world are more sceptical.

Left: Edwin 'Buzz' Aldrin (b. 1930) is credited as the second man to walk on the Moon's surface following the Apollo 11 mission. However, many believe that this and other photos were faked.

Weird Weather

One of the possible causes of UFO 'sightings' is the strange phenomenon called lenticular clouds, in which moist air crossing hilly or mountainous regions forms disc-shaped clouds that can be seen from over 50 miles away. This is a natural phenomenon that cannot be controlled by man. There are, however, certain strategies that can be defined as 'climate engineering', where it is possible to manipulate the weather.

A technique known as 'cloud seeding' was used during the Vietnam War, for example, in which the American military managed to prolong the monsoon season, thus preventing supplies getting to the enemy. Such manipulation has persuaded some people that various governments continue to use such techniques, despite it being outlawed for military purposes by the United Nations in 1977.

High-Energy Technology

Between 1990 and 2014, HAARP was a jointly managed programme of the United States Air Force (USAF) and United States Navy, collaborating on research with the University of Alaska Fairbanks (UAF). Its goal was to research the physical and electrical properties of the Earth's ionosphere, which can affect military and civilian communication and navigation systems. Conspiracy theorists suggest that in fact this facility can be, and has been, used to manipulate the weather.

Now under management of the UAF, the facility remains operational, and conspiracy theorists have alleged that the 'weather weapon' has been used to trigger floods, earthquakes and even droughts. However, in fact, HAARP cannot control the weather. Radio waves in the frequency ranges that HAARP transmits

Right: Could people mistake the lenticular-cloud phenomenon for UFOs?

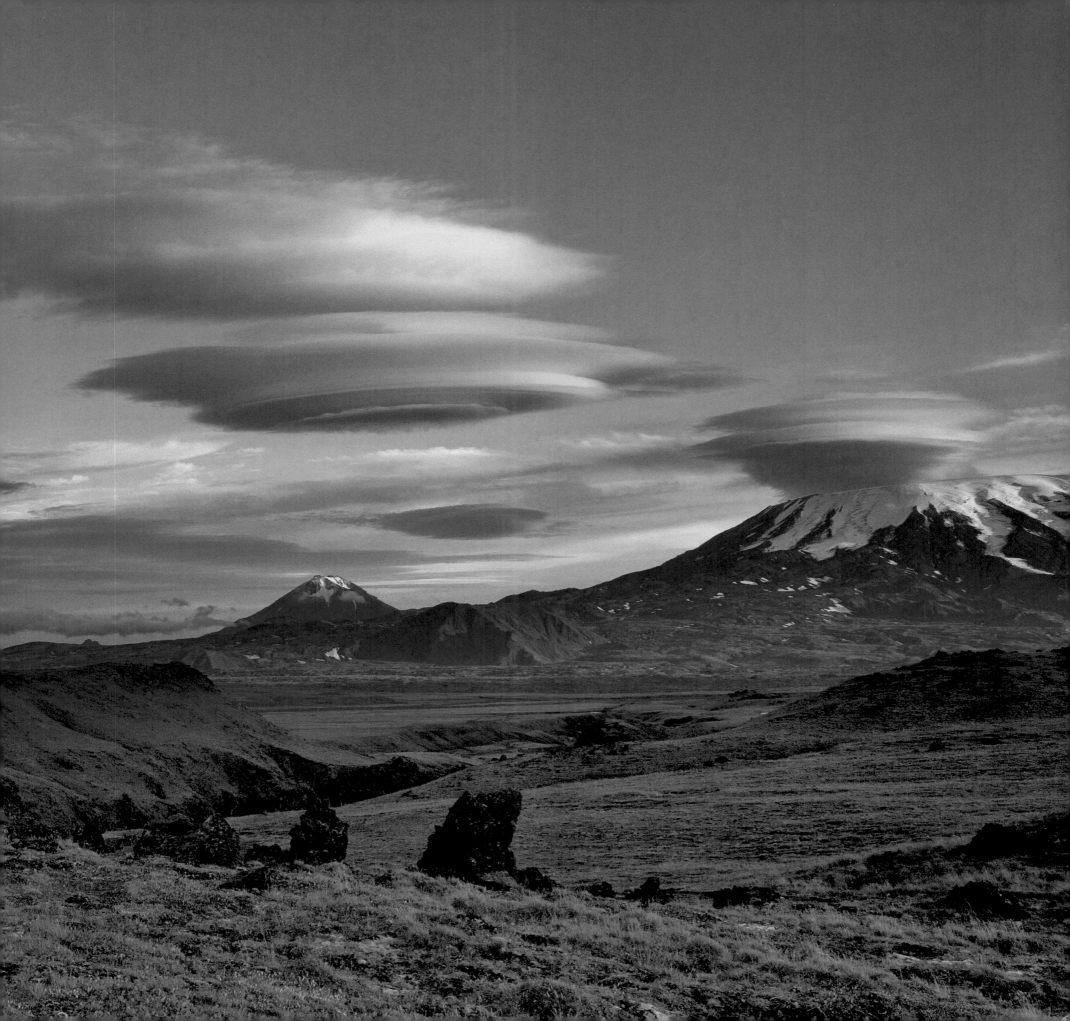

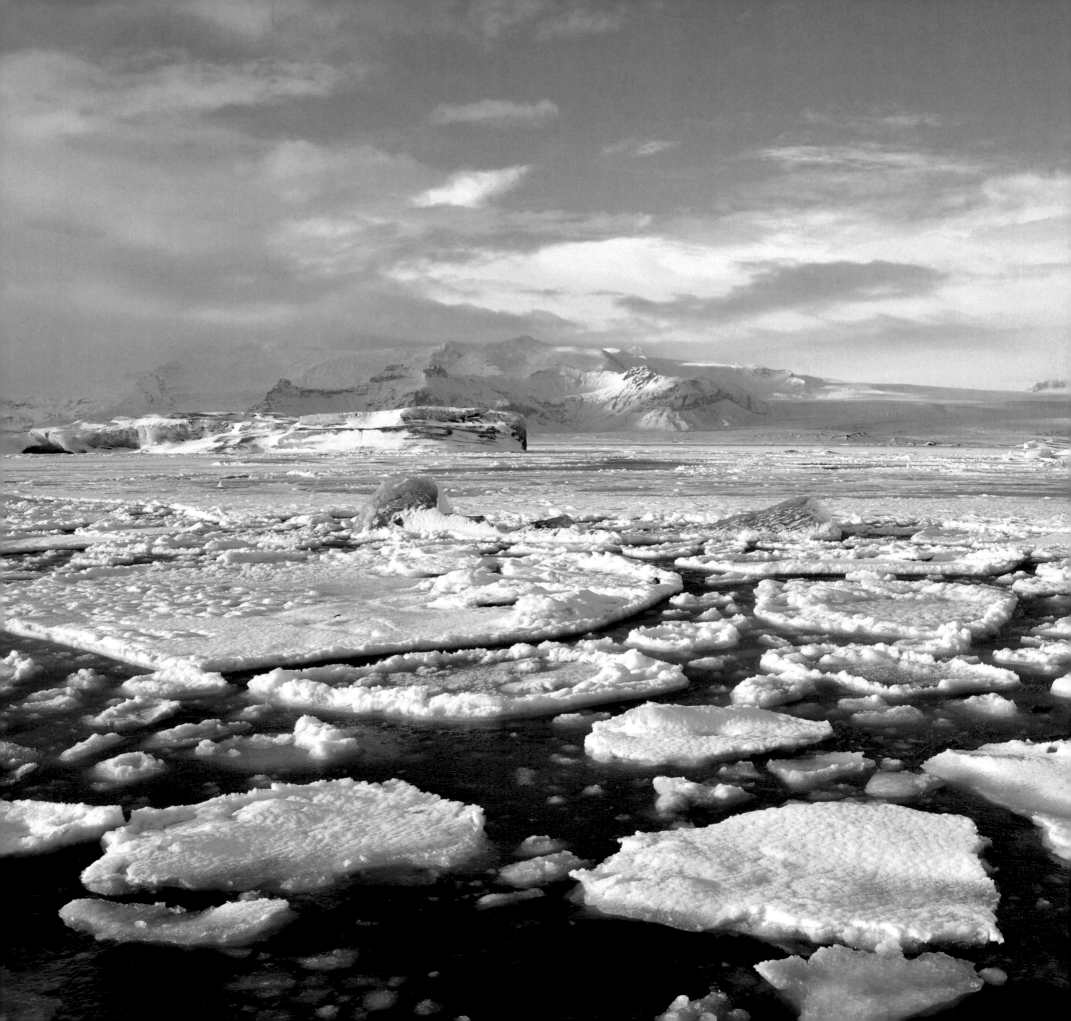

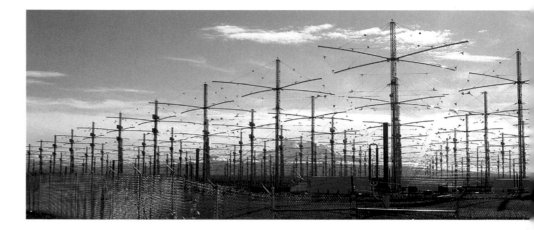

Above: Is the HAARP antenna array in Alaska responsible for weather-manipulation on a grand scale?

are not absorbed in either the troposphere or the stratosphere – the two levels of the atmosphere that produce Earth's weather. Since there is no interaction, there is no way to control the weather. The HAARP system is basically a large radio transmitter. Radio waves interact with electrical charges and currents, and do not significantly interact with the troposphere.

Other technologies have also been claimed to have been used to direct the weather. In 2017, Hurricane Irma battered the coast of Florida, causing widespread destruction. As a precaution, the Special Operation Command at Tampa was evacuated of all its military personnel, leading to the inevitable question of whether the hurricane had been directed by Maser satellites as part of a false flag attack. A Maser (Microwave Amplification by Stimulated Emission of Radiation) can be used in a satellite to direct powerful microwaves that can manipulate the weather. It has also been demonstrated that Masers can be used to create crop circles.

Global Warming and Climate Change

Today, people are divided about the issue of global warming, with scientists on both sides of the argument debating whether such a phenomenon actually

Left: Melting glaciers in the Arctic and Antarctic regions is, for many, proof of global warming. But to what extent is this natural or man-made?

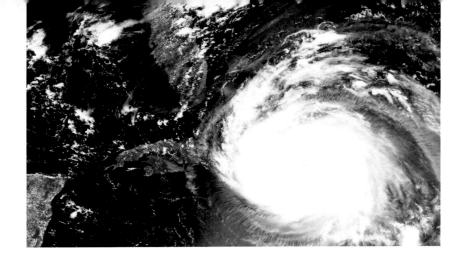

exists, and whether it is man-made. In the last 150 years, the average temperature of the Earth has risen by 0.8 degrees Celsius, which seems on the face of it a small amount, but observers have noted a rise in sea levels, melting ice caps and an increase in humidity. The correlation between the two cannot be denied. It is, however, the causes of these changes that are hotly debated. Many blame so-called greenhouse gases, such as carbon dioxide and methane, although the major contributor is in fact water vapour. These gases are retained in the atmosphere, which in turn increases the temperature of the Earth's surface by trapping reflected solar energy.

Many people blame human use of fossil fuels for the increase in greenhouse gases. Others suggest that there is evidence of global warming on other planets where there is no human activity, although this is inconclusively verifiable. The causes of global warming are more complex. It is thought that 97 per cent of the carbon dioxide in the atmosphere is created by nature, with some arguing that the three per cent caused by human activity is therefore negligible, without fully realizing that this fraction actually upsets the balance of the ecosystem.

The suggestion of a conspiracy emanates from those who wish to suppress the data about the causes, most notably those in the fossil-fuel industry. Questions arose, for example, when President George W. Bush, whose family had interests in the oil business, refused to sign the Kyoto Protocol limiting the use of fossil fuels by developed nations.

Above: Hurricane Irma's ferocity devastated large areas of the Caribbean in 2017, but was it entirely a natural event?
Right: Some sceptics question the prevailing scientific consensus about the causes of climate change; but are they right to do this?

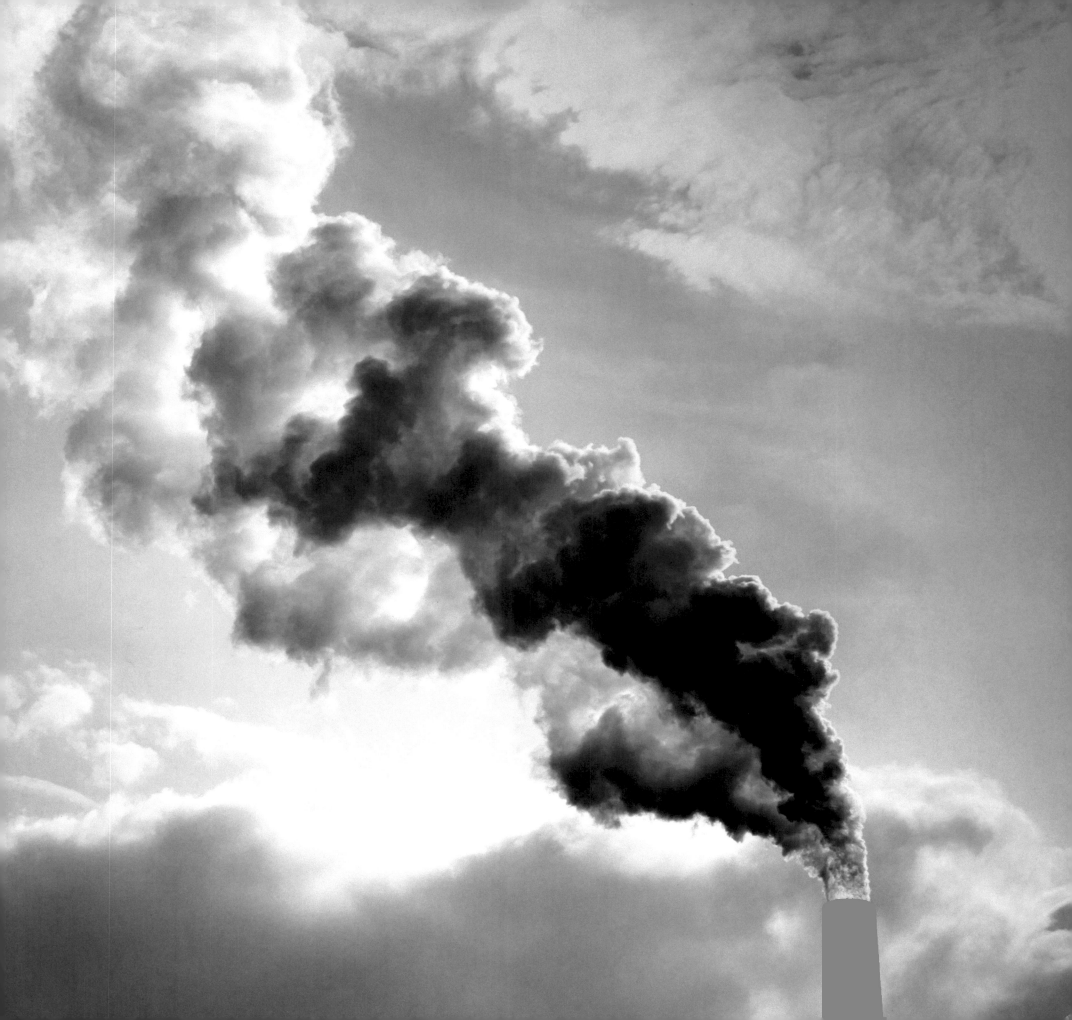

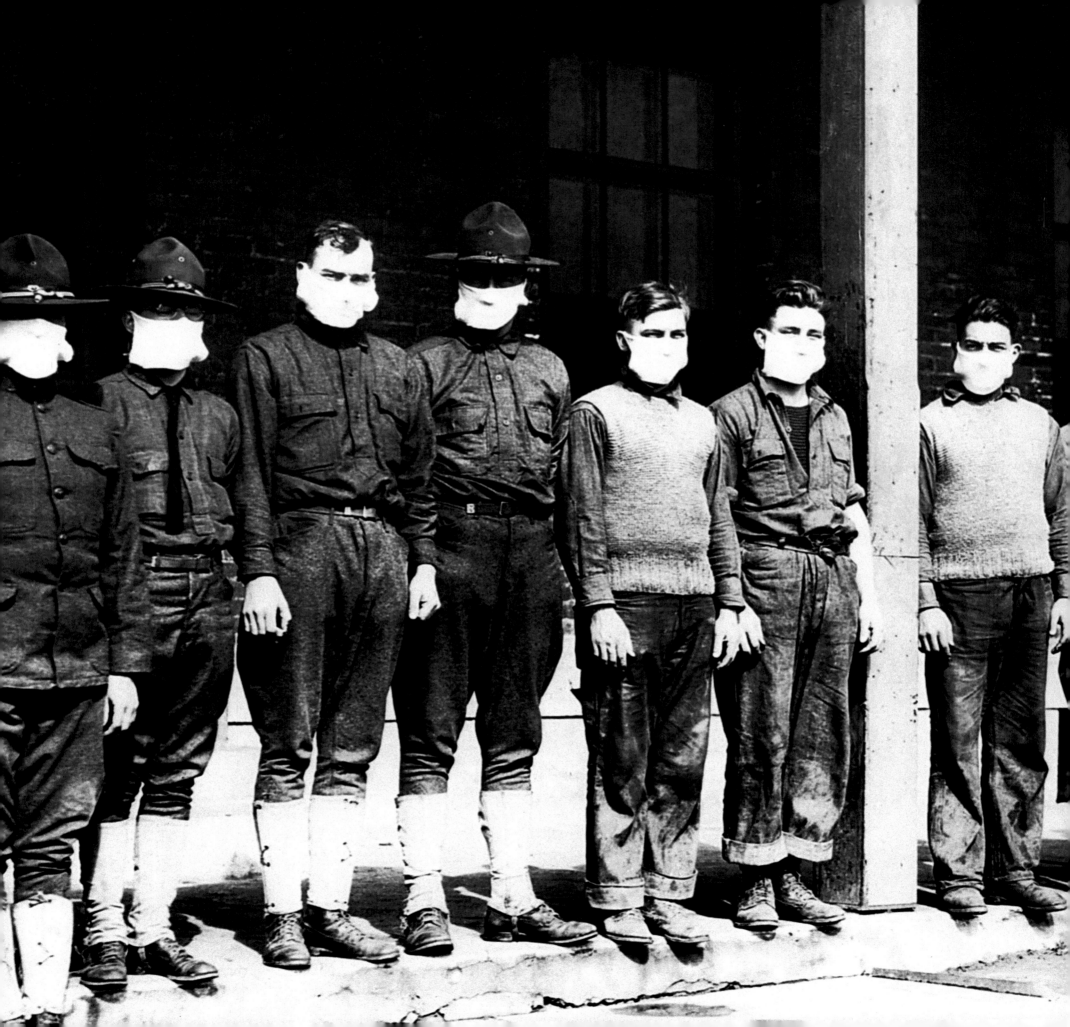

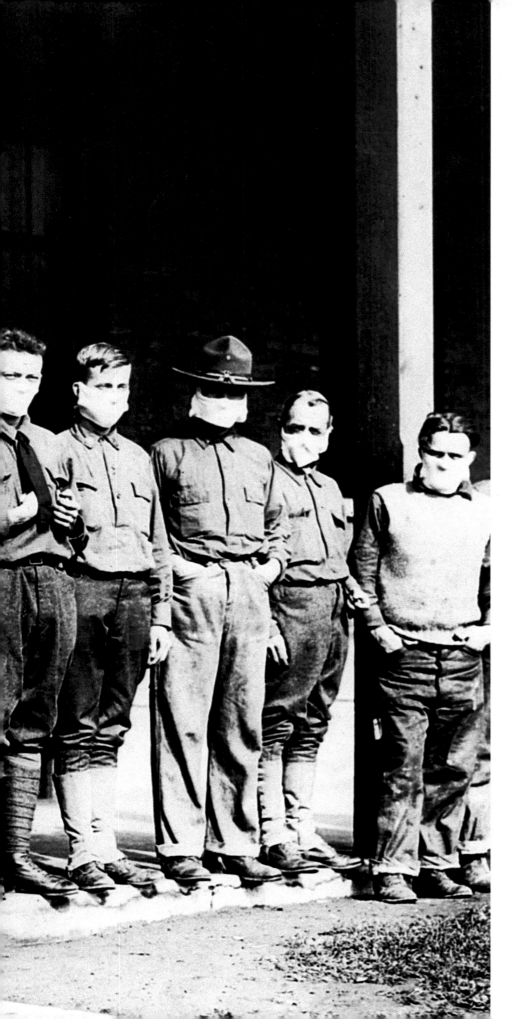

Deadly Diseases

History has shown that epidemic and pandemic illnesses have been a feature of human existence from Biblical times, and have been viewed as natural disasters rather than man-made. The most recent of the 'natural' pandemics was the Spanish Flu outbreak in 1918–20, which killed at least 50 million people worldwide.

Since then, there have been pandemics less natural in origin. It is known that the British government, for example, created biological weapons such as anthrax to be deployed against its enemies during the Second World War. Today, there are many who believe these epidemics are no longer 'natural' but specifically engineered to be used as biological weapons. For example, there are suggestions that the HIV/AIDS pandemic was a man-made culture used to destroy sub-Saharan Africa and/or homosexual practices.

HIV/AIDS

In the 1980s, a new epidemic struck the United States of America and Europe. Originally, it had been largely confined to gay men in major cities such as San Francisco and New York. The issue was highlighted when a number of high-profile celebrities died from the disease. Subsequent research revealed that the HIV/AIDS virus can be spread in a number of ways, such as blood contamination, as well as from having unprotected sex, and is not confined to men or to homosexuality.

Left: These US medics wear masks to avoid contracting the killer flu virus that swept the world between 1918 and 1920.

Most scientists agree that it originated in a non-human species such as monkeys and may well have been transmitted by the practice of eating so-called bush meat. However, not everyone is convinced by this explanation. Some believe that US scientists created the virus unintentionally while working on an experimental cancer cure during the Nixon administration in the 1970s, and infected people with it during trials. Conspiracy theorists believe that virus was then deliberately introduced into certain sections of the population, such as the LGBT and African-American communities.

The Secrets of Plum Island

In 1954, a former military base on an island in Long Island Sound, New York State, USA, was turned into an animal research laboratory, the Plum Island Animal Disease Center. At this secret and well-guarded location, a number of conspiracy theories proliferated about how the facility was being used and whether biological weapons were being created there. In 2004,

Below: Was the lab on Plum Island really responsible for creating Lyme Disease?
Right: A conceptual image of the AIDS virus, as it would appear in the bloodstream. The virus has so far claimed over 35 million lives globally, mainly in sub-Saharan Africa.

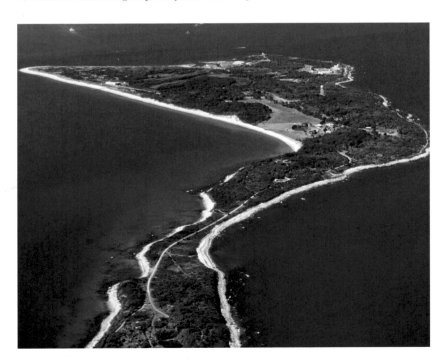

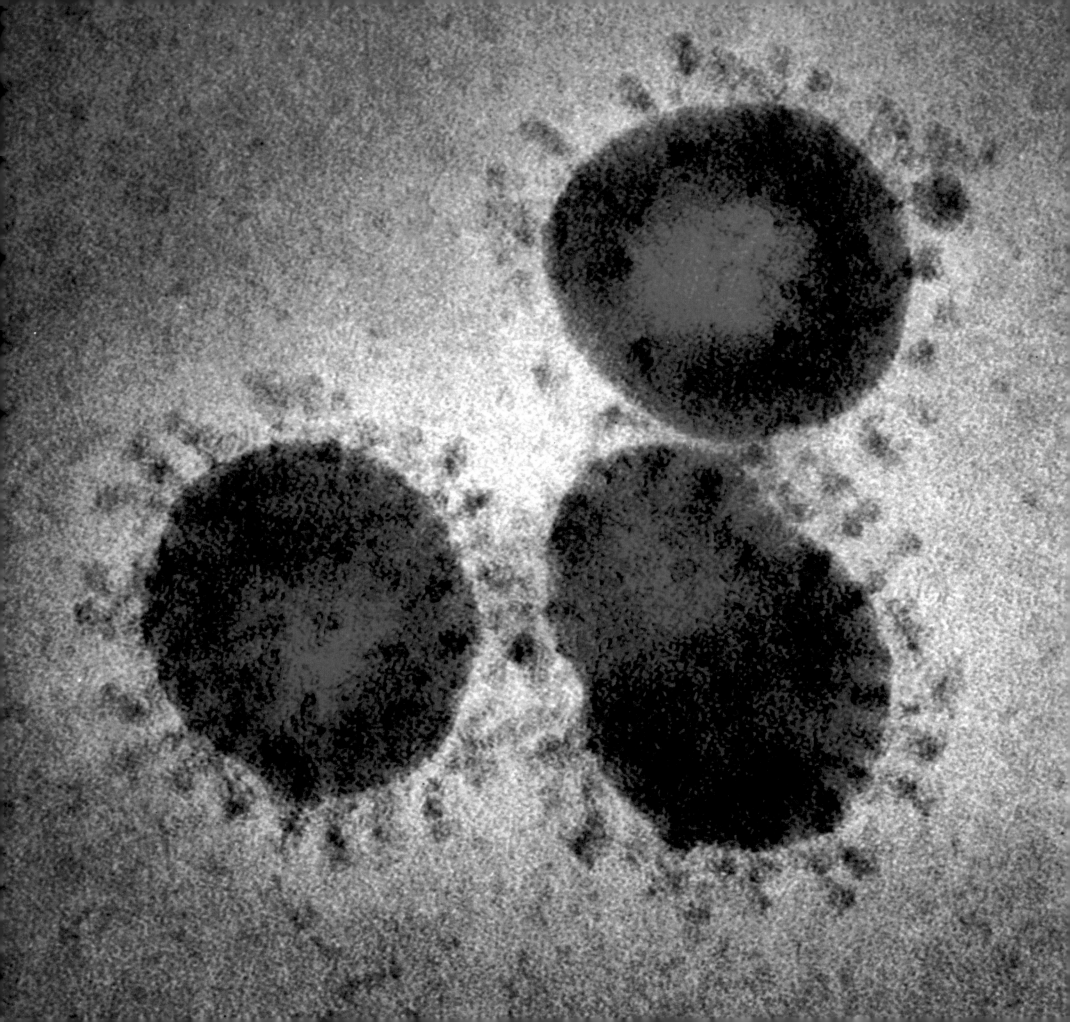

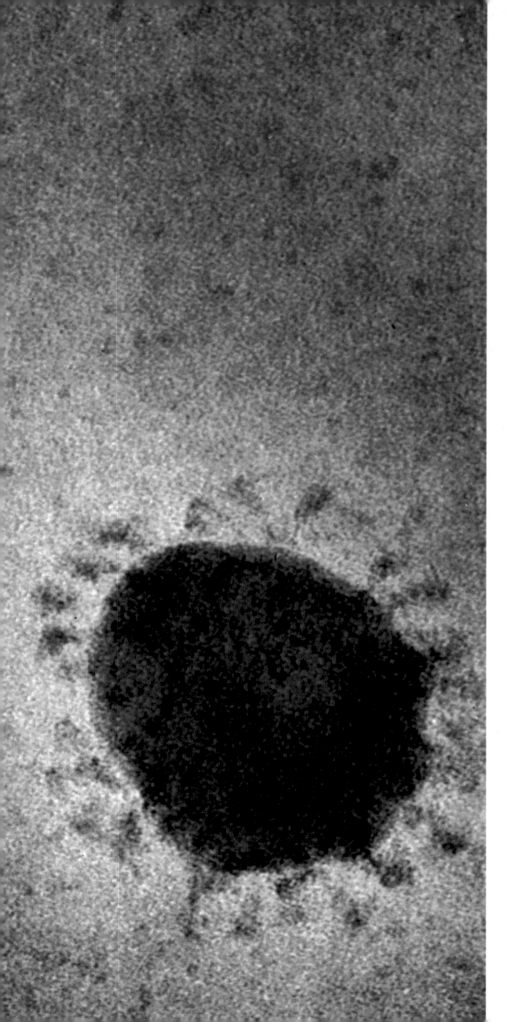

a book by Michael C. Carroll (b. 1958) was published, entitled *Lab 257: The Disturbing Story of the Government's Secret Plum Island Germ Laboratory,* in which he alleged, amongst many other claims, that Lyme disease had been deliberately created as part of a biological weapons programme. He went on to describe how, due to poor bio-security at the lab, infected ticks had been carried by birds resting on the island to estuaries of the Connecticut River in Lyme, some 10 miles from Plum Island. The disease then spread into the local population, before moving further afield.

Although rarely fatal, the tick-borne disease can be very debilitating and has continued to infect not just people in the US but also in Europe. What made the theory more plausible was the transfer of the facility from the Department of Agriculture to the Department of Homeland Security in 2003, when it became the National Bio- and Agro-Defense Facility. Security around the facility was tightened, and visitors deterred from the area. Despite repeated assurances from the authorities that all activity in the laboratory is safe and above board, the true purpose of Plum Island may never be known.

SARS Coronavirus

SARS (Severe Acute Respiratory Syndrome) was first detected in late 2002 in China with some 8,000 cases and slightly less than a 10 per cent mortality rate. Of those who survived, most have suffered some form of debility. In total, there have been 8,273 cases, with 775 fatalities. Outside of South East Asia, the virus spread to North America, with Canada suffering the worst casualties, with 251 cases and 44 fatalities – the highest percentage of deaths.

Officially, the Chinese have blamed a particular species of bat for the spread of the virus, but theories of an American conspiracy to use biological warfare

Left: The SARS virus is likely to cause a worldwide epidemic at some point, according to the World Health Organization.

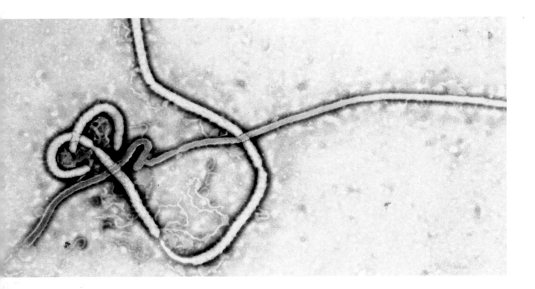

Above: The Ebola virus.

have been suggested by both Chinese and Russian scientists. Because SARS is not a naturally occurring human virus, and is linked to animal origins, it has been suggested that it is man-made, although the evidence for this remains inconclusive.

Ebola Virus

First identified as a deadly virus in 1976, the worst outbreak of Ebola was in late 2013 and lasted for 15 months, killing over 11,000 people in sub-Saharan Africa. Suggestions of a biological warfare attack by the United States were made in a Liberian newspaper. There followed further accusations that the Centers for Disease Control and Prevention (CDC) had patented the virus in order to capitalize on a cure being prepared by the pharmaceutical industry.

Although the patent was actually for the EboBun strain of the virus rather than the Ebola Zaire that was diagnosed in the outbreak of 2014, conspiracy theorists continue to suggest that there is a very real correlation between germ warfare and the huge profits to be made by pharmaceutical cures that cannot be ignored.

Right: In the absence of a cure or vaccine, quarantine is the only way to stop the spread of the Ebola virus; it will usually kill about 40 per cent of those it infects.

Conspiracy Theories: Mystery and Secrecy

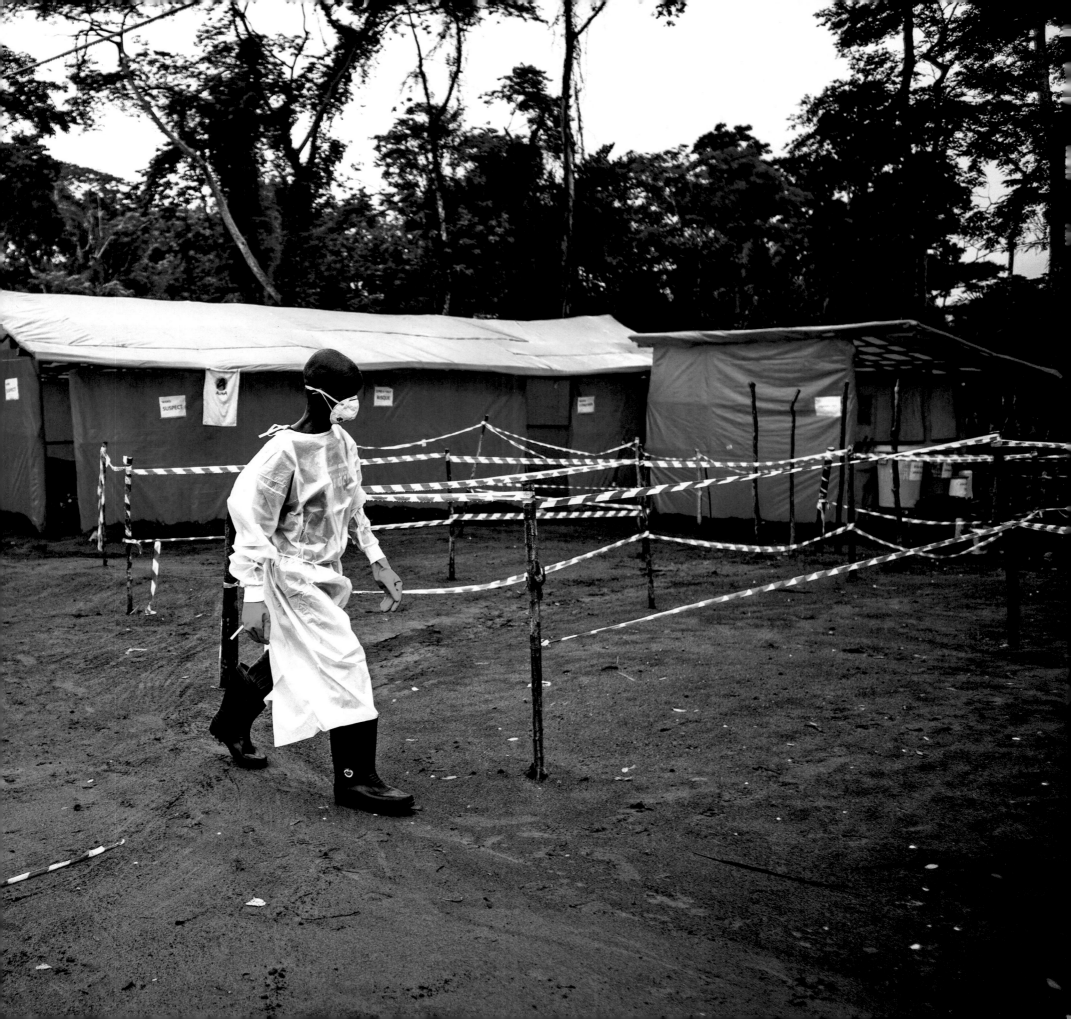

GRUINARD ISLAND
THIS ISLAND IS
GOVERNMENT PROPERTY
UNDER EXPERIMENT
THE GROUND IS CONTAMINATED
WITH ANTHRAX AND DANGEROUS.
LANDING IS PROHIBITED
BY ORDER 19

Secret Experiments

One of the most secretive government installations in Britain is at Porton Down in Wiltshire, where experiments using biological weapons are carried out. In 1942, an anthrax bacterium was cultivated there and tested on a small island in Scotland, which is little more than half a mile from the mainland. The island was littered with health-warning signs and was not decontaminated until 1990, when it was declared safe for habitation. Porton Down, one of several such sites in the world, is still operational and houses many of the most dangerous pathogens known to man. In 1976, the Ebola virus was taken to Porton Down for identification, and further experimentation was carried out to find a cure or vaccine.

Project MK-ULTRA

Since 1994, American attorney Lawrence Teeter (1948–2005) had sought to convince the authorities that Sirhan Sirhan (b.1944), the convicted assassin of Robert Kennedy (1925–68) in 1968, had been 'controlled' by the US Central Intelligence Agency as part of the MK-ULTRA programme. The project was set up in the 1950s by the CIA, with experiments on humans to establish how drugs affected behaviour and to see whether it was possible to control the mind. In the shadow of the Cold War, the project was designed to facilitate new interrogation techniques to manipulate the mind. The programme involved research in a number of institutions such as universities, prisons and hospitals in conjunction with certain pharmaceutical companies.

Left: Gruinard Island, Scotland, where a secret experiment was carried out on sheep during the Second World War to determine the possible effects of anthrax on humans.
Next page: Many theorists believe that the CIA and other secret government agencies have developed techniques for manipulating and controlling the human mind for so-called 'black operations' against its enemies.

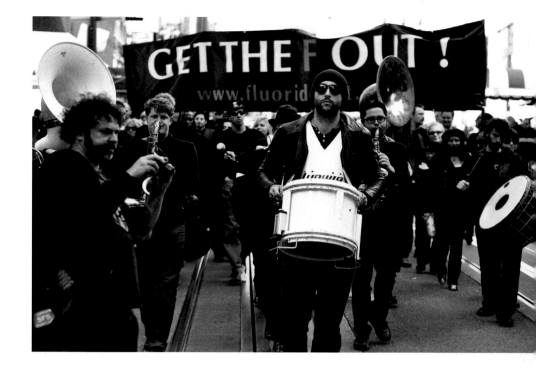

Above: Protesters marching in San Francisco, USA, in 2013, against the addition of fluoride to drinking water.

A number of conspiracy theories have emanated from this scenario, with various people claiming to have had their mind controlled by this programme. During the 1970s, the project became public knowledge and was officially terminated, but the CIA destroyed many of the documents and so it is very unlikely that we will ever know the full extent of the programme. A number of documentaries have been made on the subject and the notion of an assassin controlled by the CIA has been explored in films such as *The Manchurian Candidate* and the Jason Bourne series.

Water Fluoridation

Aside from the ethical question as to whether the compulsory use of water fluoridation by the state is an infringement of its citizens' individual rights, is the adding of fluoride safe and effective? It was decided in the 1950s to begin adding fluoride to drinking water in an effort to reduce tooth decay, particularly in children, which had reached unacceptable levels. Today,

Left:Could the addition of fluoride to water be causing insidious health problems?

approximately 70 per cent of the water supply in the US is compulsorily fluoridated; in the UK that figure is about 10 per cent, while in the rest of Europe it is less than three per cent. There seems little doubt that fluoride does actually help prevent tooth decay, but many toothpaste manufacturers now add it to their products, and this is considered by many to be sufficient.

Scientists, however, debate the safety of adding fluoride to drinking water, because of its toxicity, particularly as sodium fluoride is used as a pesticide. It has also been suggested that it has an adverse effect on IQ levels and may be a contributor to ADHD. The main conspiracy theory surrounds its original use in America in the 1950s at the suggestion of Gerald Cox (1895–1989), the director of the newly formed National Institute of Dental Research in Pennsylvania. In the 1930s, Cox was a researcher working for the Mellon Institute and was charged with investigating the toxicity of the smelting process of aluminium on behalf of The Aluminum Company of America (ALCOA). It was known at that time, and had been reported by various journalists, that the fluoride residue from the smelting process was causing human deaths by ingestion. The investigative journalist Christopher Bryson (b.1960) suggested in his book *The Fluoride Deception* (2004) that the need to find an answer to the industrial pollution issue and to deal with the dental health problem was not just coincidental, but one that was specifically orchestrated by Cox and others, at the behest of the US government.

Eugenics

It was the English polymath Francis Galton (1822–1911), a cousin of Charles Darwin (1809–1882), who first coined the term 'eugenics'. Fascinated by Darwin's work, Galton proposed the idea that the genetic quality of humans could be improved by selective breeding. Programmes were in place in the early twentieth century to develop the so-called 'Eugenic Philosophy' in many Western societies, but its later association with Nazi ideas

Right: Could state-authorized eugenics be a way to control populations in the future?

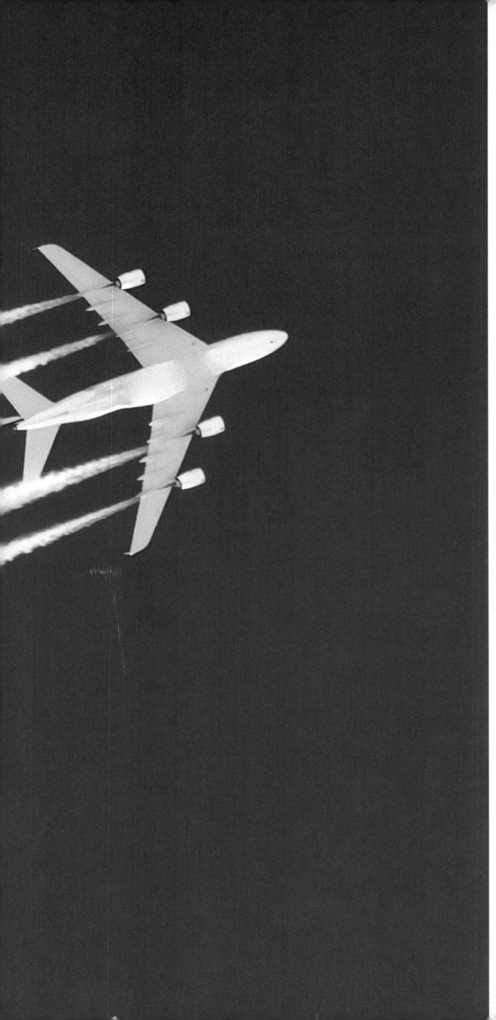

made it unacceptable. The stigma attached to 'fit' and 'non-fit' eugenics and subsequent human rights legislation have ensured that such abuses have been curtailed, but not eradicated.

Experiments continue using what is now known as neo-eugenics, ostensibly to enhance human characteristics and capacities in parental choices. This is often referred to as 'liberal eugenics', since the choices made are those of the parents as opposed to those of the state. However, some conspiracy theorists have suggested that these technologies could be used by government agencies to control society and its citizens, making them little more than state slaves.

Chemtrails

The vapour trails of high-altitude aircraft that can be seen from the ground are, according to conspiracy theorists, loaded with chemicals that are undisclosed to the public. According to scientists, these are nothing more than condensation trails, but according to the theorists, condensation would normally dissipate far more quickly without leaving such a noticeable trail. These trails have earned the tag 'chemtrails' as opposed to the scientists' preferred term 'contrails' – an amalgam of 'condensation' and 'trail'.

According to the theorists, these chemicals have been used for climate engineering, mind-control experiments and even population management through the use of biological warfare. The theory began with the admission by the United States Air Force that it had been involved in weather manipulation, leading many people to express their anger at such a practice. Since the government has already confessed to cloud seeding to manipulate weather (HAARP), theorists have suggested that other manipulations using aircraft are a distinct possibility and that these may well be part of a global conspiracy.

Left: *The condensation trails, or 'contrails', from aeroplanes have often been cited as possible 'chemtrails', secretly dispersing chemicals into the atmosphere for nefarious purposes.*

Technological Conspiracies

We are currently living in what is variously called the Age of Information, or the Computer or the Digital Age, when more and more of our tedious decision-making can be undertaken by machines (computers and robots). The patterns of our lives, such as where we shop, where we holiday and how we use our leisure time, are stored as digital information, both openly and covertly. These databases have the capacity for helpful assistance and supporting our wellbeing, but could also be used against us in a malevolent way. However, many pioneers of new technologies such as Nikola Tesla (1856–1943), the inventor of alternating current, have been the targets of neo-Luddites. Tesla was the first to patent the idea of using solar energy, but had the reputation of a 'mad scientist', making it easy to discredit him.

Free Energy and Peak Oil

One of the main current sources of energy is oil and, unsurprisingly, oil barons such as the Rockefeller family have sought to suppress ideas of 'free' energy. A geologist working in the oil industry, Marion Hubbert (1903–89), coined the term Peak Oil in 1956, predicting when the production of oil was likely to peak before its decline in availability. This data has been used by the industry to control both the output and price to its advantage. The energy business is a multi-billion-dollar industry that wishes to maintain its monopoly. In 2006, a documentary called 'Who Killed the Electric Car?' was aired, alleging a conspiracy between the Bush administration (many ofwhom were involved in the oil industry), the car industry and certain

Previous page: Did Nikola Tesla have the right idea? Is solar power a solution to our energy requirements?
Right: Oil accounts for about one third of all global energy resources. Many believe those in the trillion-dollar oil business have deliberately hampered progress towards finding greener alternatives.

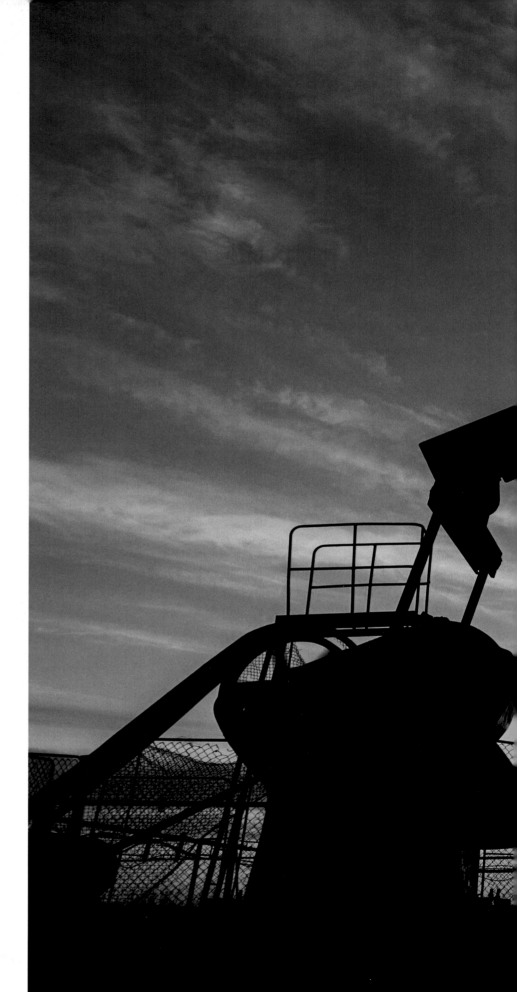

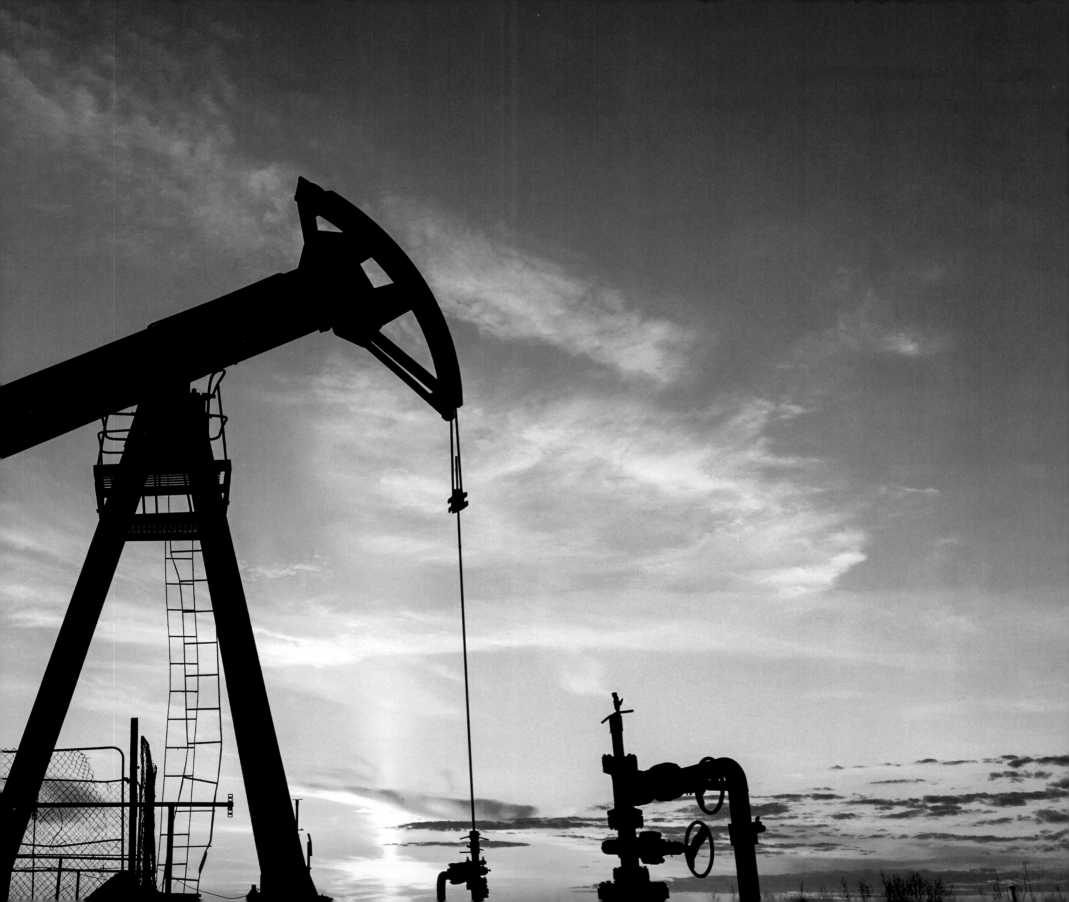

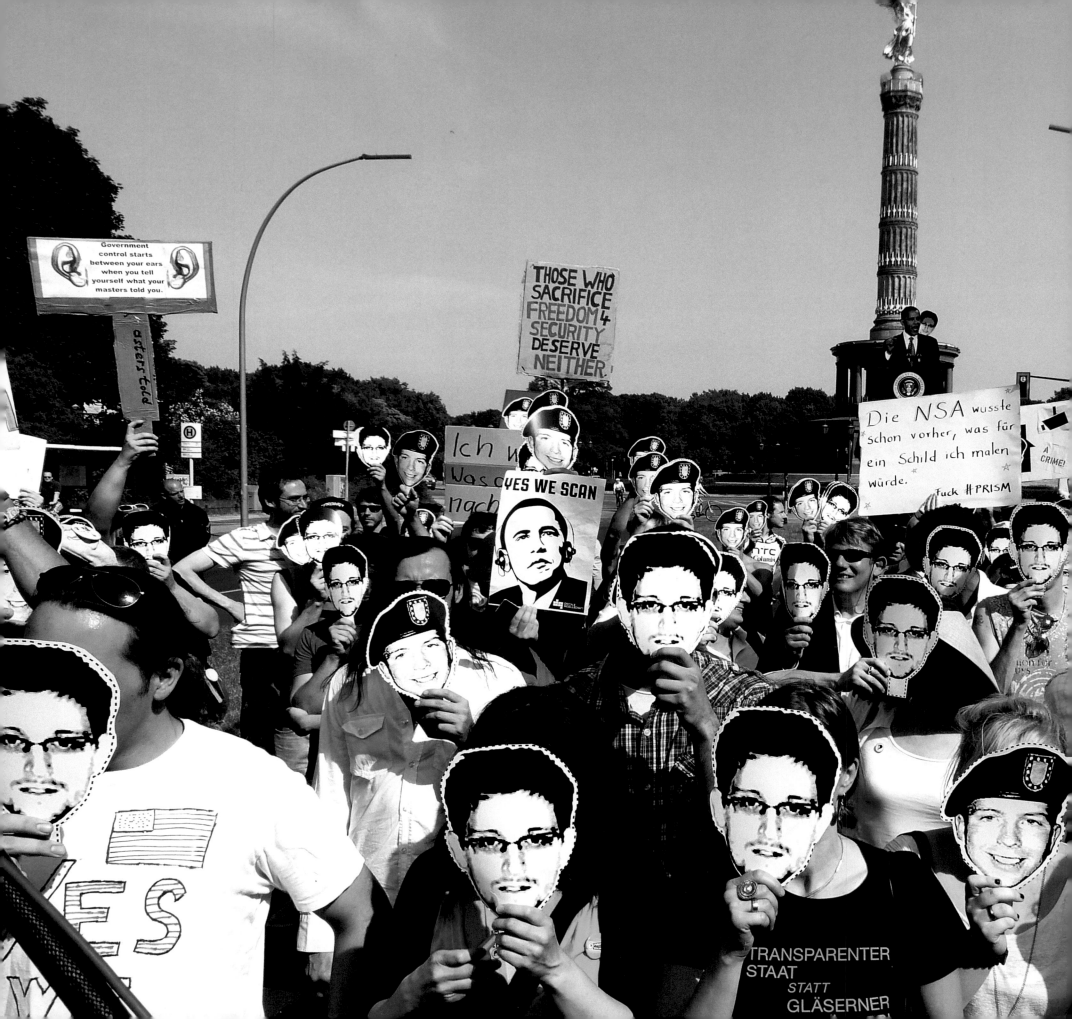

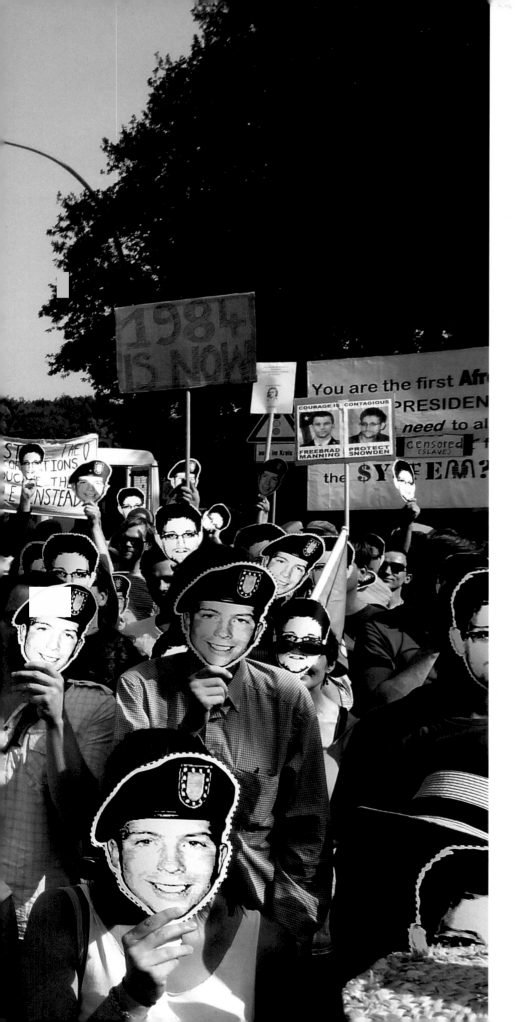

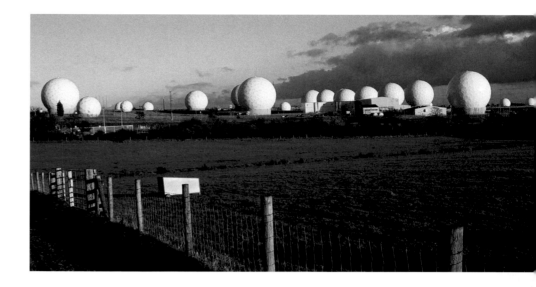

celebrities to discredit the making of the General Motors EV1 and cut off any further funding for the development of electric cars.

Global Surveillance

In 2003, a former CIA and National Security Agency (NSA) employee, Edward Snowden (b. 1983), flew to Hong Kong and released top-secret intelligence about global surveillance operations perpetrated by the so-called Five Eyes group of countries, comprised of the US, UK, Australia, New Zealand and Canada. Snowden is now living in Moscow and seeking asylum. The Global Surveillance programme was initiated following the 9/11 attacks, but was not formerly ratified until 2007, under the codename PRISM as part of the Protect America Act. The purpose of the programme, which is run with the support of Apple, Microsoft, Google and Facebook, is to collect internet data for use in the prevention and detection of terrorism and serious crime. This programme has led to allegations of infringements of civil liberties and free speech, but, on a more sinister level, is seen as Big Brother Orwellianism.

Above: Radomes (housing radar antennae) at RAF Menwith Hill, UK, a site enabling communications interception believed to be used by the ECHELON surveillance programme operated by the US with the aid of the rest of the Five Eyes countries.
Left: Demonstration against PRISM in Berlin.

Planned Obsolescence

In 1924, the Phoebus cartel was set up by a group of the leading light-bulb manufacturers, such as Osram and General Electric. Until this time each light bulb lasted for approximately 2,500 hours. The cartel conspired to create a bulb that would last a maximum of 1,000 hours, which then became the industry norm for the rest of the century. This is seen as the first case of so-called planned obsolescence in manufacturing, when companies could create a product knowing its probable life to project future sales. It was also an opportunity to fix a standard price that remained unchallenged until Far Eastern manufacturers began to provide cheaper, but generally less reliable, products.

Today, the original cartel members have developed new technologies using 'long-life' LED bulbs that are supposed to last longer, are more energy-efficient, but also considerably more expensive. Other manufacturers have followed suit with planned obsolescence that affects kitchen white goods, smartphones and computers. Software development is also colluding with these manufacturers to ensure that the consumer is always buying the latest model, since new applications are not always compatible with the older hardware.

Above: Are we, the consumers, benefiting from new technologies, or simply being duped into buying the latest model?
Right: The light-bulb conspiracy in the 1920s saw major manufacturers forming a cartel and actually building a determinate obsolescence into their products.

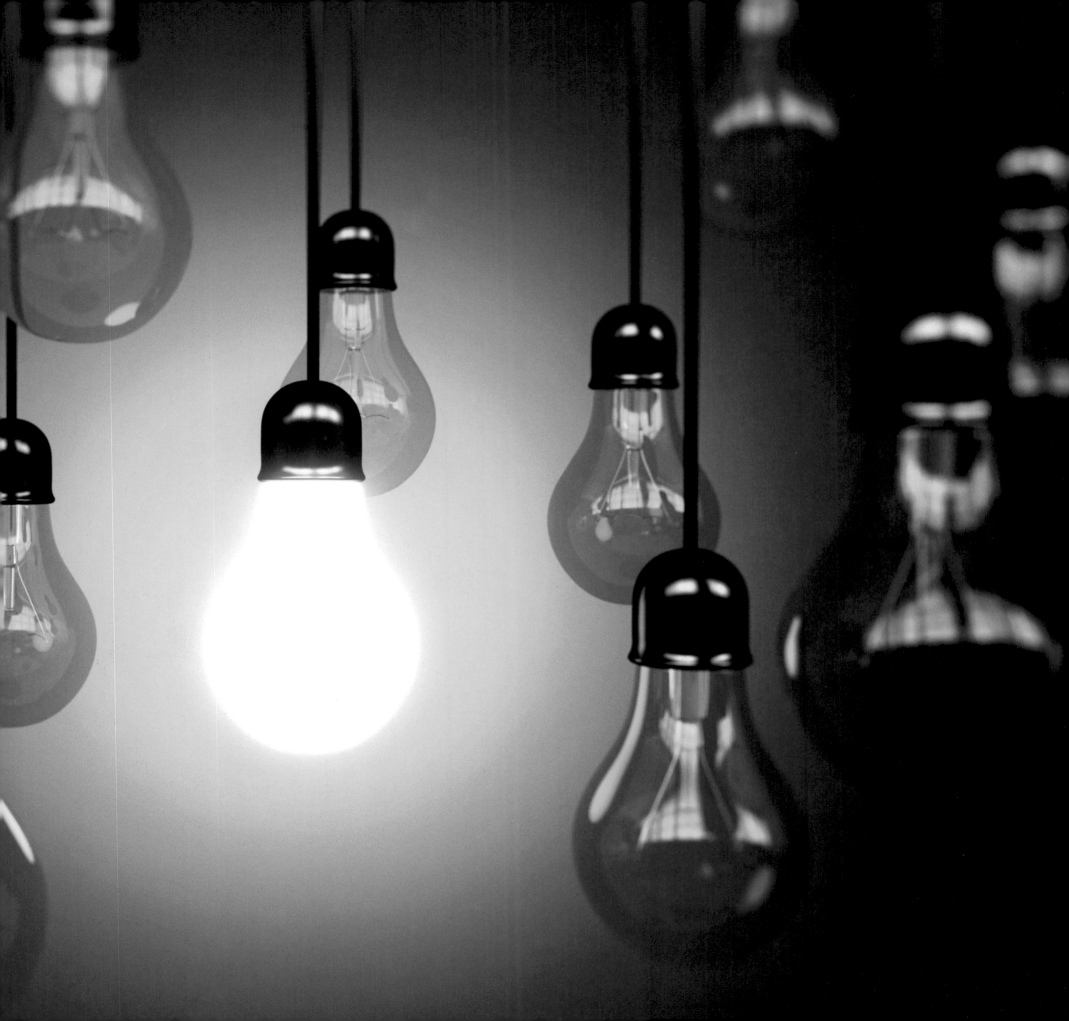

The Food We Eat

One of Britain's best-known writers and journalists on the subject of food and how it is purchased and consumed, Joanna Blythman (b.1956), wrote *The Food We Eat: The Book You Cannot Afford to Ignore* in 1998. It is just one of many that is critical of food standards and exposes how supermarkets conspire to hoodwink consumers in their buying decisions and shopping habits. In the West particularly, we no longer eat just because we are hungry, but for a variety of other reasons such as lifestyle and cultural influences that encourage us to overeat with the resultant health issues such as obesity and Type-2 diabetes.

The Cowspiracy

In a documentary released in 2004 called 'Cowspiracy: The Sustainability Secret', its makers suggested that the livestock industry is environmentally destructive. Their agenda was to persuade its audience that veganism was the only appropriate choice to make when considering food options. Their concerns were the livestock's heavy use of water and feed that could be used for human consumption, its contribution to global warming, and deforestation to provide feeding habitat for animals. They produced a number of statistics showing why meat production was so harmful to the environment, the most alarming of which was that dairy animals contributed 51 per cent of all greenhouse gases. There have been several subsequent rebuttals of the evidence from various scientists and also from the environmental group Greenpeace, who state that the methane produced by animals' digestive systems is about 18 per cent of all greenhouse gases. Nevertheless, accepting that there is some hyperbole in the documentary data and that the makers' sole aim was to convert the

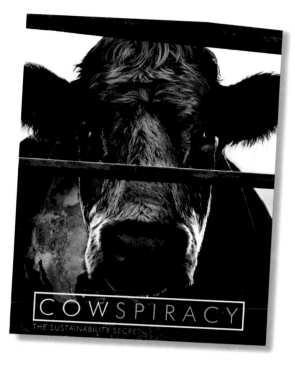

audience to a totally vegan diet, they have highlighted a key question: How can the human race provide and sustain the food supply for its seven billion population?

Genetically Modified Crops

One of the largest so-called 'agri-businesses' is Monsanto, a biotech corporation that is a leading player in genetically modified crop production. The production of Genetically Modified Organisms (GMOs) is highly contentious despite their being consumed since the late 1990s and a scientific consensus that they are no more harmful to humans than conventionally grown crops. One conspiracy theory suggests Monsanto is concealing the true data that shows GMOs are harmful because of the adverse effects on its business; and that it also conspired with the Food and Drug Association (FDA) to provide evidence of its safety. On a more general level, it has yet to be established whether the production of GM crops is harmful to the environment or not.

Above: 'Cowspiracy' aimed to highlight the question of the long-term sustainability of the livestock industry.
Right: A biohazard sign at the edge of a cornfield shows that the crop is a genetically modified organism. Such signs also appear on foodstuffs that contain GMOs.

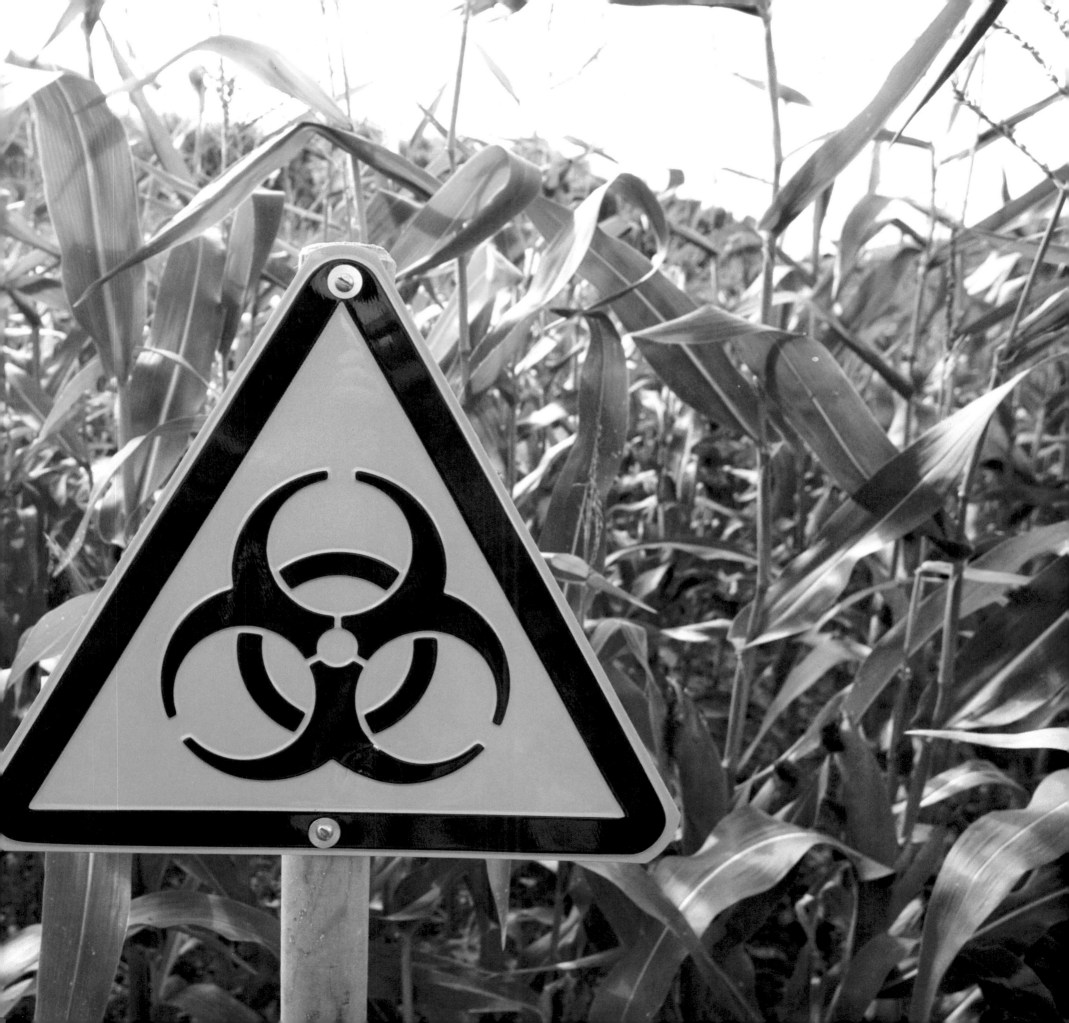

The Sugar Conspiracy

In post-Second World War America, there was a growing awareness of obesity in society, with two culprits being blamed – sugar and fats. In 1965, the Sugar Research Foundation (SRF) commissioned a group of scientists to investigate the phenomenon and, unsurprisingly they found that saturated fats were the main culprit, while downplaying the effects of sucrose. Fifty years later, journalists have revealed that the sugar industry was complicit in a cover-up of the harmful effects of sugar, misleading the food industry by publishing their findings in the *New England Journal of Medicine*, thus contributing to food policy for half a century. As recently as 2012 the world's largest producer of sugary drinks, Coca Cola, has also tried to deflect interest away from sugar as a main contributor to obesity by using scientific reports to state that people should fixate less on calories and more on a balanced diet and regular exercise. Nutritionists are critical of the tactic, since public bodies such as the Academy of Nutrition and Dietetics and the American Society for Nutrition form partnerships with companies such as McDonalds and PepsiCo.

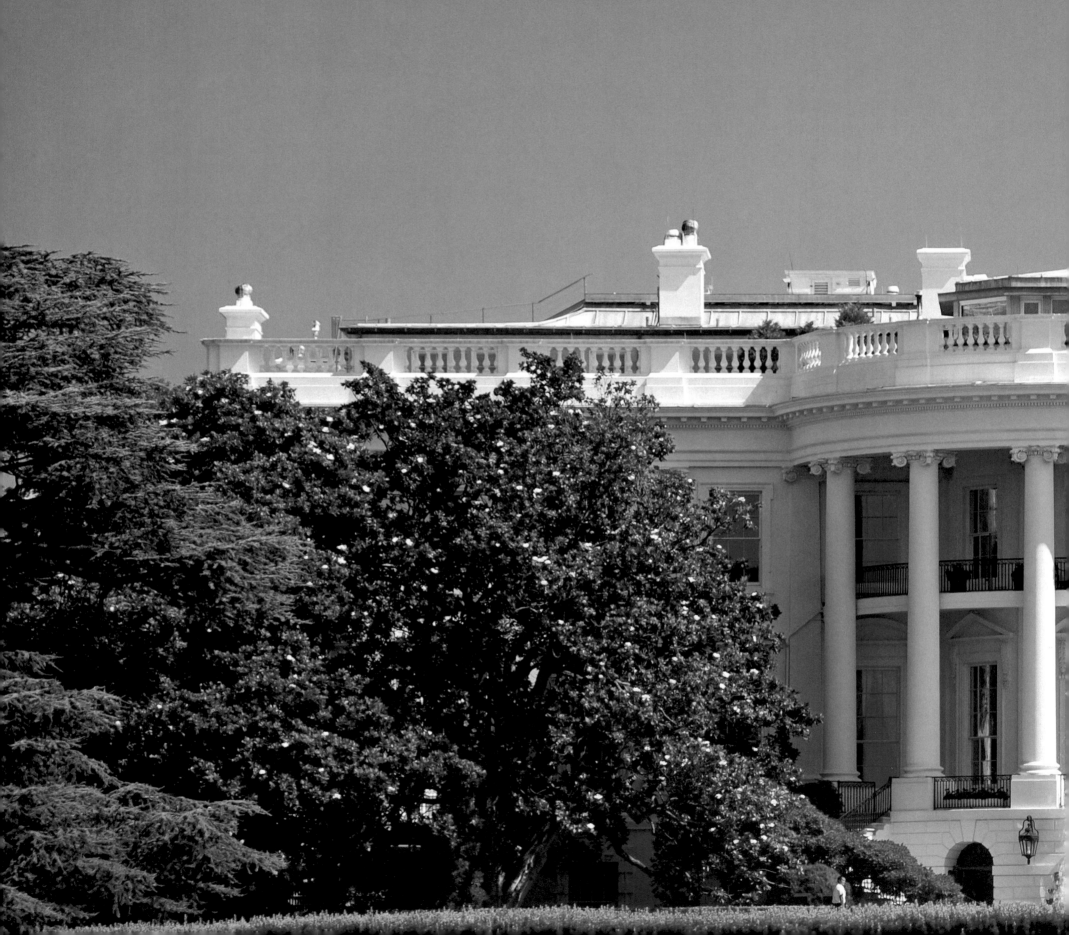

Political Conspiracies

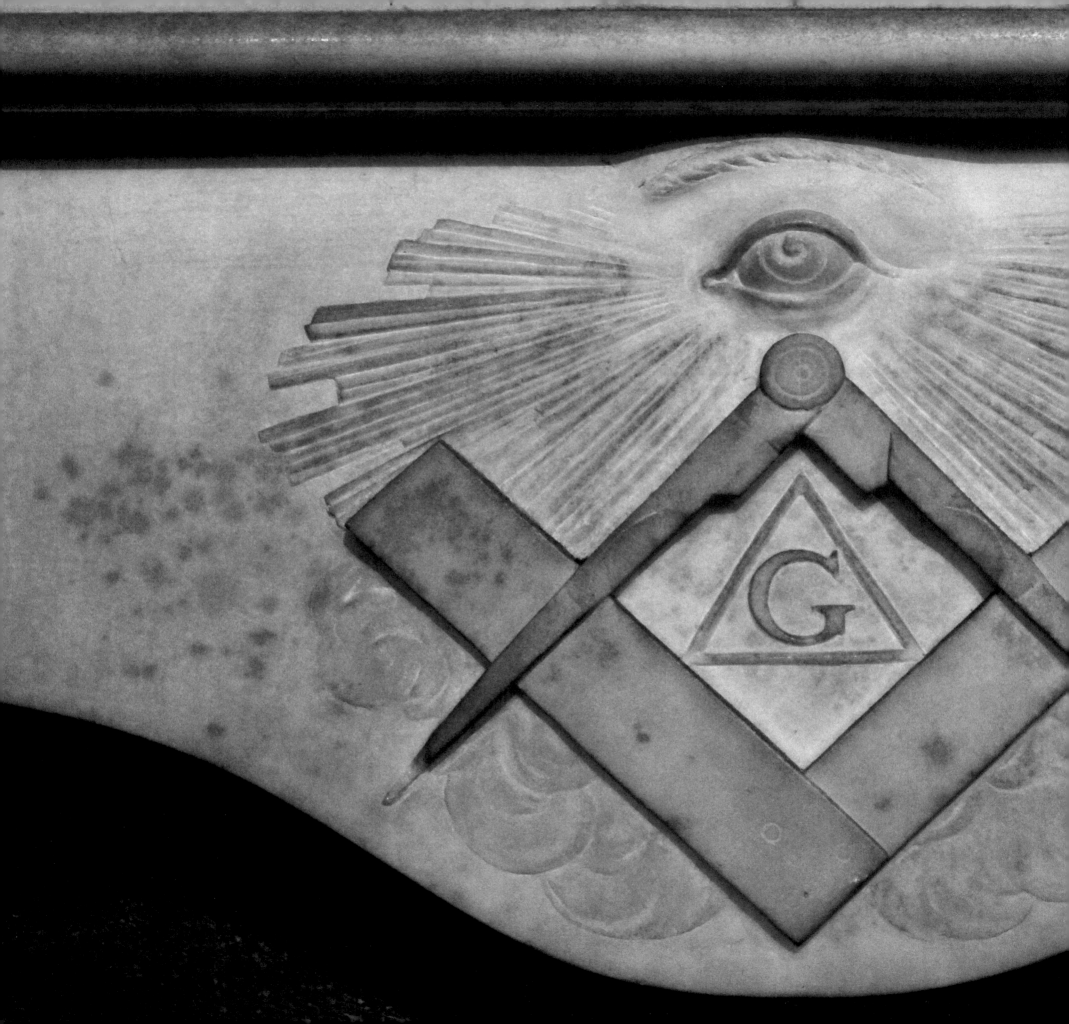

Secret Societies

One of the key aspects of, and contributors to, conspiracy theories is the question of secrecy. Of course, all companies and governments need to keep secrets, but at the time of a disaster or heightened security, questions will always be asked about certain agencies' willingness to disclose sensitive information. Some so-called secret organizations such as the Freemasons are known about, although their activities are a closely guarded secret. The Illuminati are totally secret and many perceive their activities to be malevolent, while others question their very existence.

A key symbol used by the Freemasons and the Illuminati is the Eye of Providence, also known as the 'all-seeing eye'. Its earliest iconographic use was during the Renaissance, but more significantly, it appears on the United States one-dollar note together with the Latin motto *Novus Ordo Seclorum* ('A New Order for the Age'). Is it just a coincidence that the Illuminati were founded in 1776, the same year America declared its independence from British rule?

Left: The Freemasons' Masonic Square: ritual and symbolism is integral to this ancient fraternity.
Below: Johann Weishaupt, founder of the Order of the Illuminati.

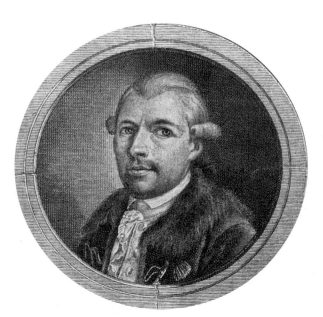

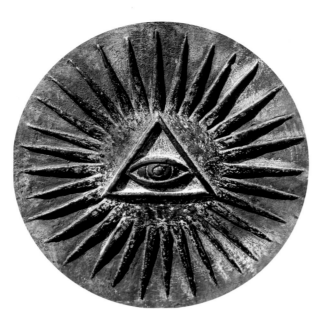

Freemasonry and the Illuminati

The German philosopher Johann Weishaupt (1748–1830) founded the Order of the Illuminati as a secret society in 1776. Its objectives were to oppose the use of religion as an influence in public life and eliminate the abuse of state power. Weishaupt's ideas were based on another secret society, the Freemasons, which he found was not compatible with his own anti-religious ideas. The Illuminati under Weishaupt were effectively shut down by the Bavarian state under pressure from the Roman Catholic Church, soon after the society's inception, but many believe they were involved in the French Revolution and are still active today. A key theory is that the Illuminati dominate and control the banking system. Speaking in 1802, one of the founding fathers of the US, Thomas Jefferson (1742–1826), warned the American people that 'banking institutions are more dangerous to our liberties than a standing army'.

One of the main tenets of theorists concerning both the modern Illuminati and Freemasons is that there is a core group of elitists who want to control and manipulate the world's population by owning all the resources, such as finance, education and the media. Both of these organizations are allegedly involved in conspiracy theories around the notion of a New World Order.

Above: The All-Seeing Eye, fundamental to both the Freemasons and the Illuminati, but who is it looking at?
Right: A nineteenth-century French engraving depicting a supposed 'Initiation of an Illuminatus'.

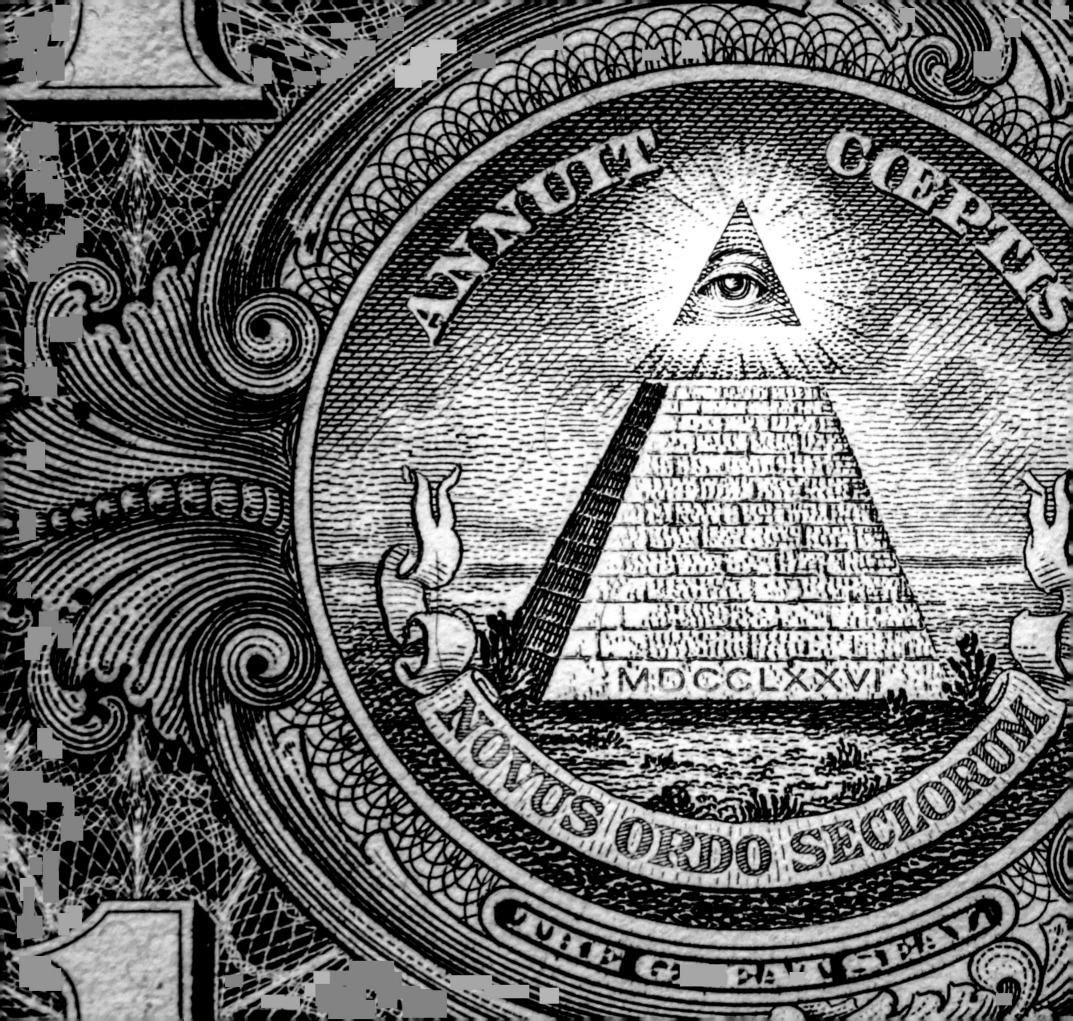

Ancient Reptilian Elite Theory

David Icke, a leading conspiracy theorist, has suggested and indeed argued that, for centuries, human awareness of our purpose on Earth has been manipulated to the point where we are little more than slaves. According to Icke, the continuous and tyrannical control of our food, water and air supply through substances added to them has ensured the subjugation of the population by the elite. He suggests that those in power emanate from a carefully controlled bloodline that makes up the so-called 'ruling class' and includes royal families, presidents, prime ministers and financiers. Icke's ideas are taken from Biblical texts and folklore, and suggest that millennia ago, man's DNA was manipulated by alien reptilian beings so that they could control human existence.

The New World Order Theory

According to conspiracy theorists, the Illuminati seek a New World Order in which the whole planet is governed and controlled by them. Everything would be centralized, with no individual nation states, and religion would be carefully integrated into and controlled by this totalitarian New World Order. Until the last decade of the twentieth century, this conspiracy was limited in America to two factions: the anti-government military and those anticipating the 'end of time' and the arrival of the Antichrist.

In 1991, following the fall of Communism, the Christian writer and broadcaster Pat Robertson (b. 1930) refers in his book *The New World Order* to a 'behind-the-scenes' establishment consisting of Freemasons, Illuminati, The New Age Movement, banks and other financial institutions, and the Trilateral Commission, whose agenda is to create a one-world government. Some theorists have pointed to the fact that successive American presidents

Left: *To some conspiracists, the presence of the Eye of Providence (associated with both the Freemasons and the Illuminati) on the dollar bill is further evidence of the malign influence of these organizations over the US government.*

have repeatedly used the expression 'New World Order' since the fall of Communism. It is believed by some that underneath Denver International Airport is a large underground city where the New World Order government will be located.

The Bilderberg Group

Set against the backdrop of the Cold War, this clandestine group was founded in 1954, and brought together key Western figures to promote the ideals of Atlanticism, the support for a close relationship between the United States, Canada and Europe. Its founder was Prince Bernhard of the Netherlands (1911–2004), who organized an annual meeting of key figures from industry, finance and politics to discuss world affairs behind closed doors. Each year, there are between 120 and 150 delegates who participate by invitation only in a conference designed to debate issues without passing any resolutions, taking votes or issuing policy statements. Conspiracy theorists, who often congregate outside the meeting's venue, suggest that there is something altogether more sinister going on – an agenda for a one-world government. One of the reasons the conspiracy theories started was that, until recently, the group's activities were not reported in the mainstream media.

Above: *It is suggested that politician and businessman Cecil Rhodes (1852-1902) first mooted the idea of a one-world government, based on an Anglo-American alliance, back in 1891.*
Right: *The 2016 meeting of the Bilderberg Group in Germany saw many protestors outside the complex, believing this elite group to be behind the New World Order. Note the 'Eye of Providence'.*

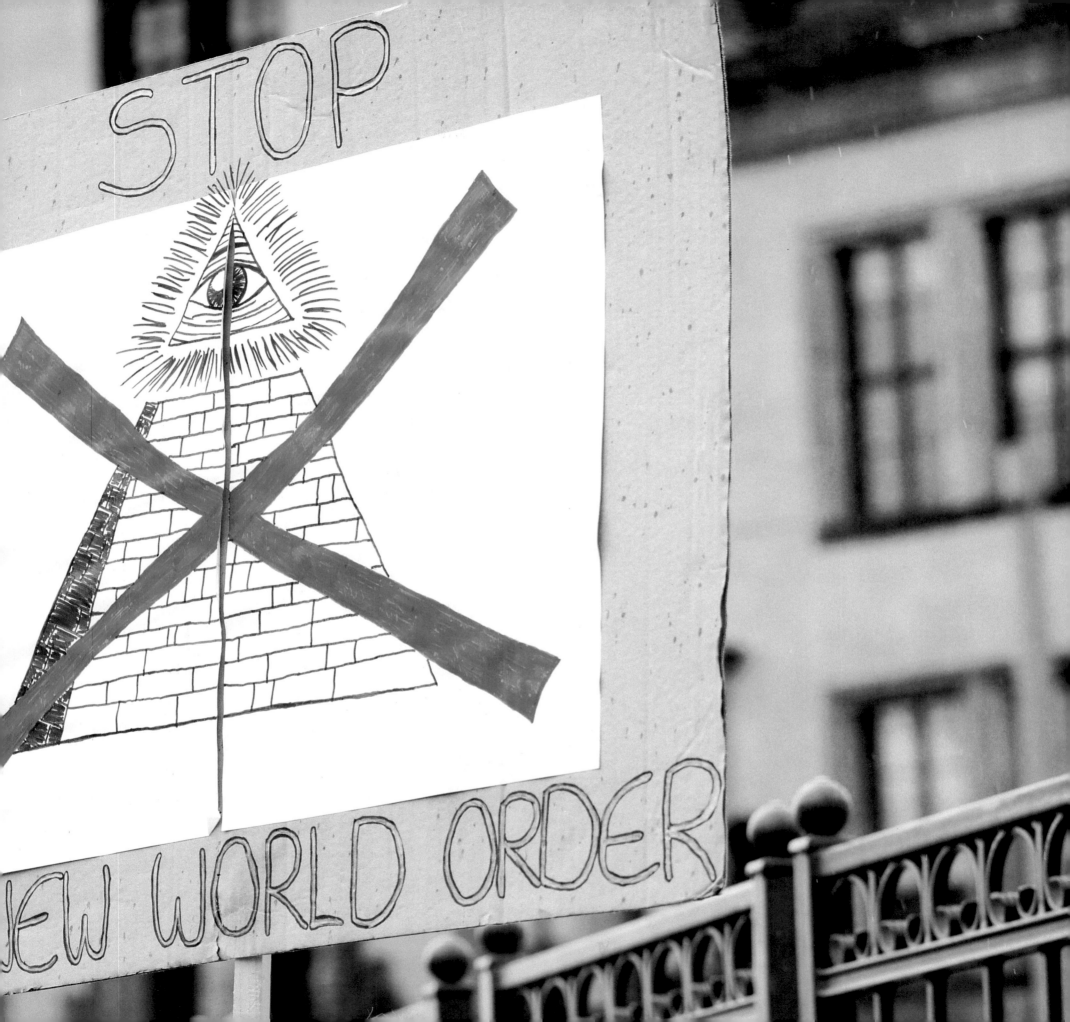

Above: *George W. Bush, alumnus of the Skull and Bones Society.*

Skull and Bones

Skull and Bones is a secret society founded in 1832 that selects its members from the graduates of Yale University, known as 'Bonesmen'. Their meeting hall, known as the 'Tomb', is windowless and its activities are an absolute secret. Many of its carefully selected members are of the 'elite' and include George Bush Snr and Jr, who have each recruited Bonesmen into their administration. Bush Jr and John Kerry (b. 1943), both Bonesmen, ran against each other in the presidential campaign of 2004. Bonesmen have included three US presidents and many other prominent politicians: founding member of the Central Intelligence Agency (CIA) James Jesus Angleton (1917–87); Harold Stanley (1885–1963), co-founder of Morgan Stanley; and Henry Luce (1898–1967), founder and publisher of *Time* magazine. Despite Yale becoming co-educational in 1969, Skull and Bones remained a male bastion until 1992, when its committee very narrowly voted to allow women to become members.

Left: *The 'Tomb': postcard of the Skull and Bones Society building, Yale University.*

Military Operations

There must always be secrecy surrounding a military operation, to provide the element of surprise. However, in the case of Pearl Harbor, conspiracy theorists believe American authorities had advance warning of the attack and yet took no evasive action. Secrecy would have been paramount to the success of the Philadelphia Experiment carried out by the US military to make ships and other large weapons invisible to the enemy, even at close range. Then there is the secrecy concerning veterans returning from war. In some cases, they are celebrated and rewarded with medals of honour, but what about their physical and mental state? Do governments do enough to help, or as theorists posit, do they try to cover up their maladies?

Pearl Harbor

The surprise attack by Imperial Japanese forces on the American fleet at Pearl Harbor, Hawaii in December 1941 left over 2,400 Americans dead and brought the United States into the Second World War. But to what extent was the US government aware of this 'surprise' attack? Between 1941 and the end of the war, the US held a number of enquiries into the incident, plus a congressional hearing at the end of the war that concluded that the United States had been incompetent, through a lack of communication between the army and navy and a gross underestimation of Japanese military capability.

People who have investigated the attack over many years have concluded that the United States government had foreknowledge of the event and allowed the scenario to play out, because Roosevelt wanted his country to be involved

Right: The USS Shaw explodes during the Pearl Harbor attack in December 1941. How much prior knowledge of the strike did the US government have?

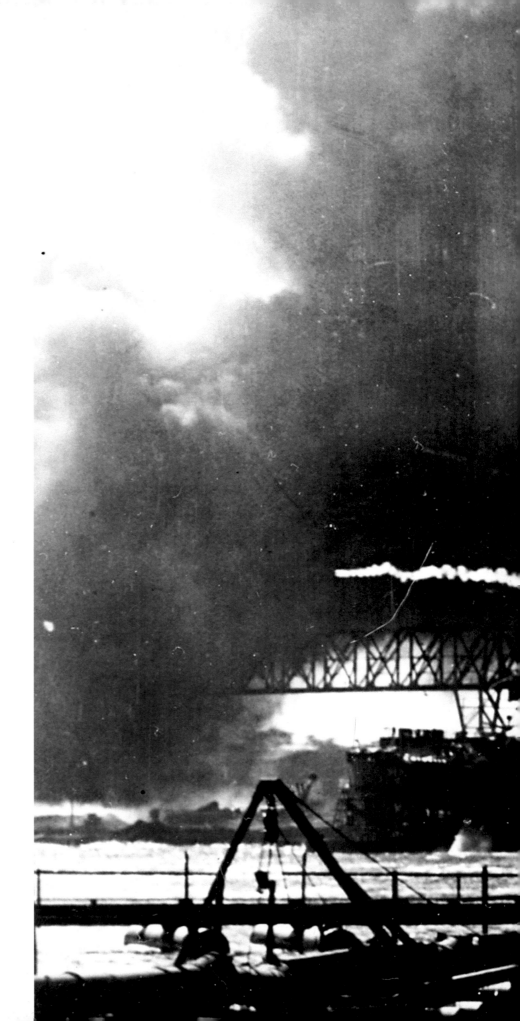

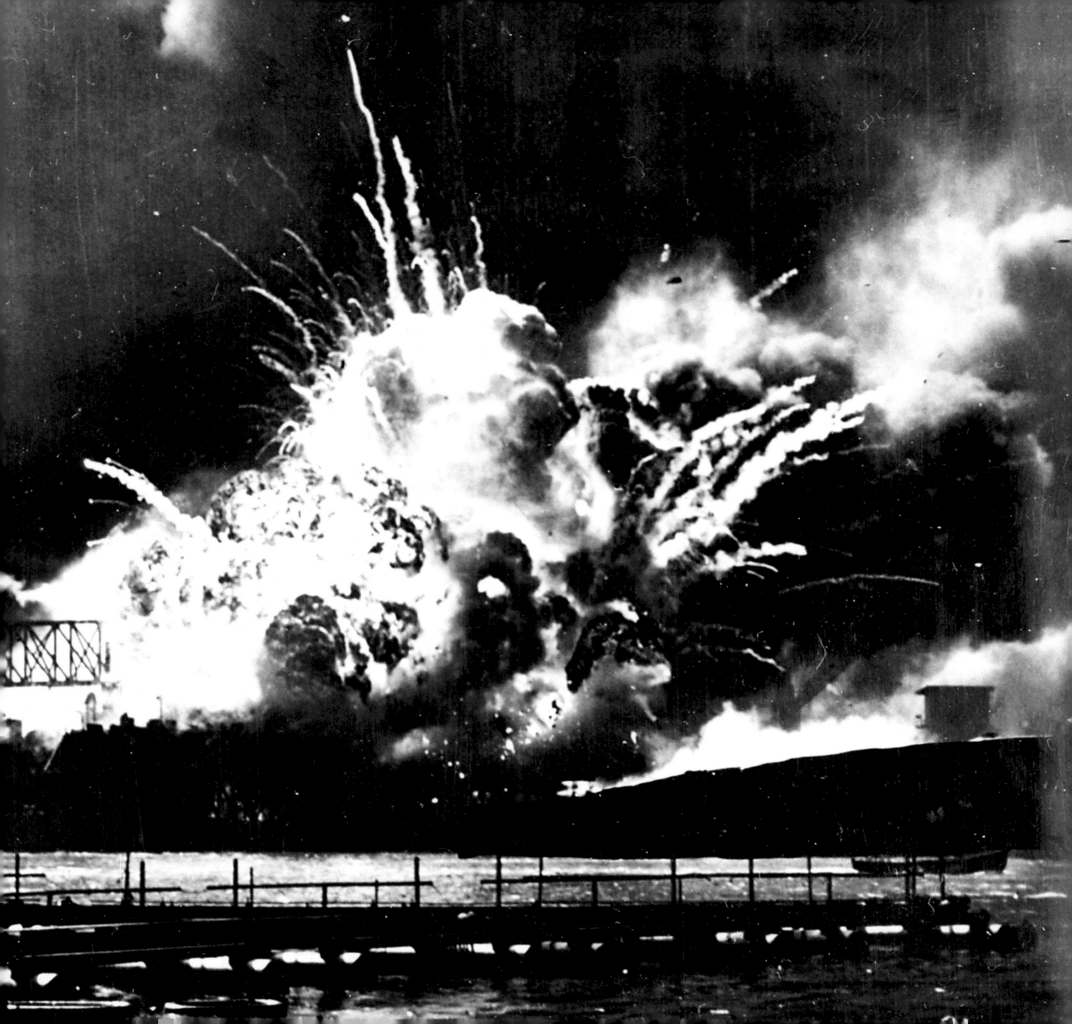

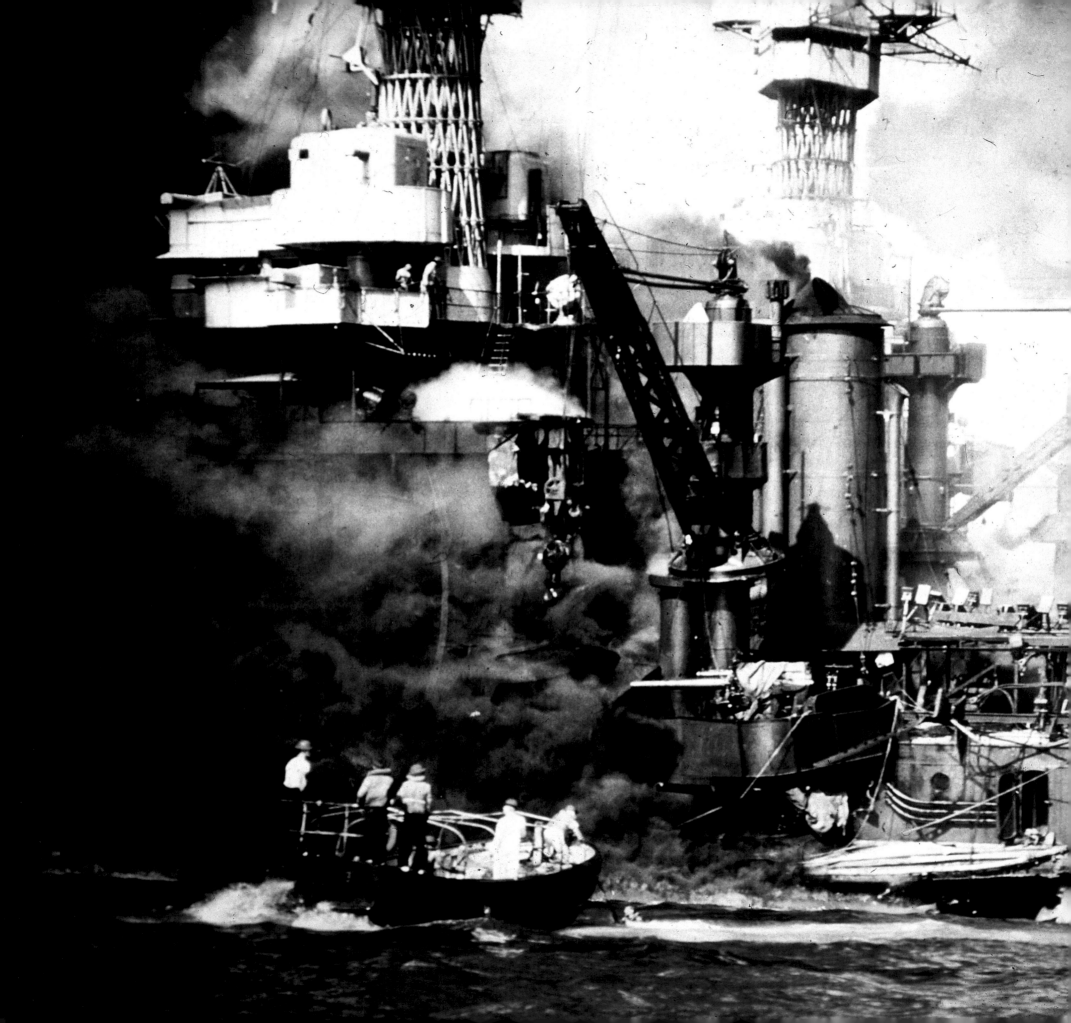

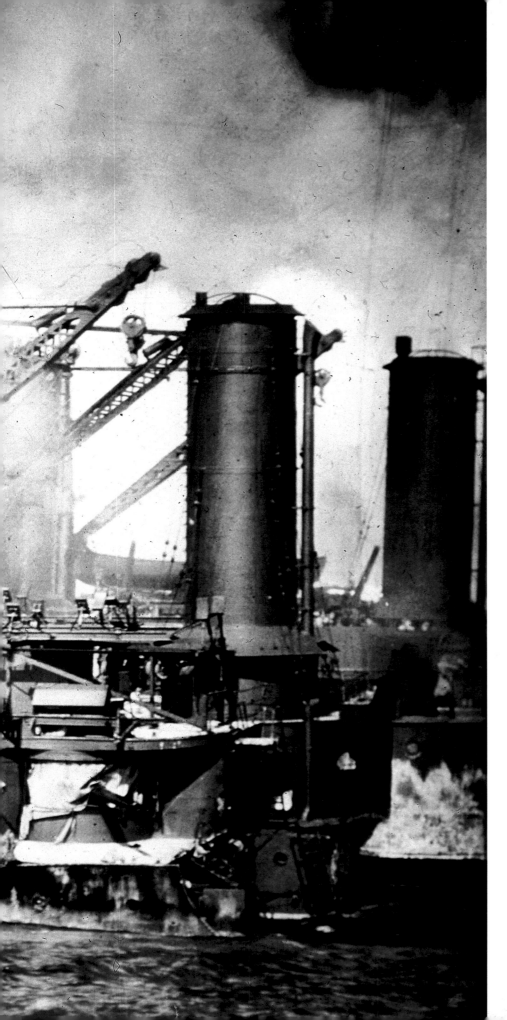

in the war. It is known that Germany and Japan were sharing top-secret information about the war, and America had intercepted a so-called 'Purple' (encrypted high-level) message in June 1941 advising Japan that Germany was about to invade the Soviet Union. Conspiracy theorists have therefore concluded that Roosevelt must have been aware of the imminent strike at Pearl Harbor, since they would have been able to decrypt Japanese messages.

The Philadelphia Experiment

In October 1943, a military experiment is alleged to have taken place at the naval shipyard in Philadelphia, in which the destroyer USS *Eldridge* was made invisible to the enemy. Despite the navy's denial, the story has, since 1955 when it first broke, been the subject of a conspiracy theory. The story alleges that, using Einstein's Unified Field Theory, it is possible to render a ship invisible. Eyewitness accounts

Left: Eighteen ships were sunk or run aground during the Japanese attack at Pearl Harbor, 1941.
Below: A still from the film The Philadelphia Experiment, *made in 1984, that hypothesizes what actually happened to the destroyer USS Eldridge and the ship's crew in 1943.*

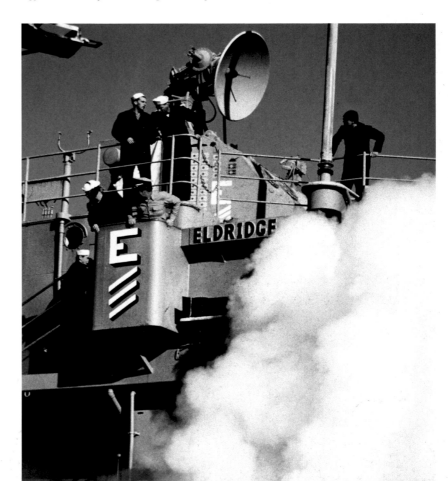

vary from the ship being 'invisible' to it being wrapped in a 'green fog', while some of the sailors on board complained of nausea and others suffered mental illness.

It has been suggested by the conspiracy theorists that the sailors were then subjected to some form of hypnosis to silence them about the experiment. Other theorists have suggested the navy repeated the experiment with a successful teleporting of the vessel to Virginia, where it was seen from another naval vessel before being teleported back to Philadelphia. While the science behind this is purely speculative, the Philadelphia Experiment continues to fascinate people and the scenario has been used in many science fiction stories.

Gulf War Syndrome

It was decided to send a coalition military force, led by the US, into Iraq in 1990 following its invasion of Kuwait. Most people in the West considered it a necessary military venture to embark on what later became known as

Right: *This copy of M.K. Jessup's* The Case for the UFO *contains many unattributed annotations relating to knowledge of, amongst many subjects discussed in the book, the existence of aliens, UFOs and confirmation of the physics behind the Philadelphia Experiment. Who was responsible for these mysterious notes?*
Below: *British troops are shown here in 1991 receiving injections to ameliorate the effects of chemical warfare, but many question whether side-effects led to Gulf War Syndrome.*

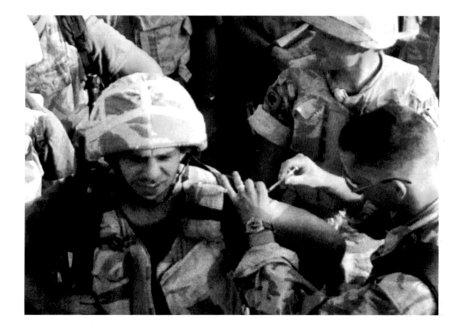

& I know the cause of this flight & Am Not
disturbed Paris Exhibition, 1951, Scientist
from a Paris University Demonstrated this.
An AP PHOTO WAS SENT TO U.S. SHOWING THIS
ACTION.

U.S. NAVYS FORCE-FIELD EXPEIRMENTS 1943
OCT. PRODUCED INVISIBILITY OF CREW & SHIP. (Mr. A)
FEARSOME RESULTS. SO TERRIFYING AS TO,
FORTUNATELY, HALT FURTHER RESEARCH.

We went through similar compelling experiences with regard to falling
(9)
stones, falling live animals, and falling animal or organic matter. We
found that life arriving from the sky was almost universally of a low order,
such as reptilian or aquatic, and we found that some of it involved such
intellectual elements as functionality, localization of target and repetition
in fixed areas. The only common denominator for all the observed conditions
turned out to be—of all things—hydroponic tanks in space craft!

 ON THE HEAD! (Mr. B)

 And if we are confronted with a falling object of crystalline rock
obviously shaped as an optical aid, are we to cravenly call it an erratic,
and discard or ignore it? And are we to cringe before the deposition of a
few hundreds of dead birds from the heavens, all on one city, but of species
completely scrambled and mostly unknown within hundreds of miles of that
city?

 What would you do with a piece of meteoric iron, unmistakably shaped
by intelligent hands, but which was equally unmistakably removed from solid
formations of the geological Tertiary Age of 300,000 years ago? Wouldn't
you perhaps reshuffle your conception of the antiquity of intelligence and
wonder whether it was, for a fact, indigenous to this planet?

 If you found raw meat, with hair attached, falling over a two-acre
space, from a clear and undisturbed sky, wouldn't you struggle even harder
to find some kind of category for it, and a common denominator of explanation
relating it with other phenomena?

 SPOILED FOOD, DROPPED. (Jemi)

 If you found that water sometimes arrives from the sky in solid masses,
flooding little brooks until they washed away villages, but neglecting the
brooks a half mile away, wouldn't you look for a category outside routine
meteorological storms?

 These problems all had to be faced. Something had to be done about
them—and they all arose from objects falling from the sky. Also, they
had to be distinguished from meteorological storms—for some of the clouds
which we studied just appeared, spat a stone or two and passed on. They
were not thunderstorms. What were they? (A)

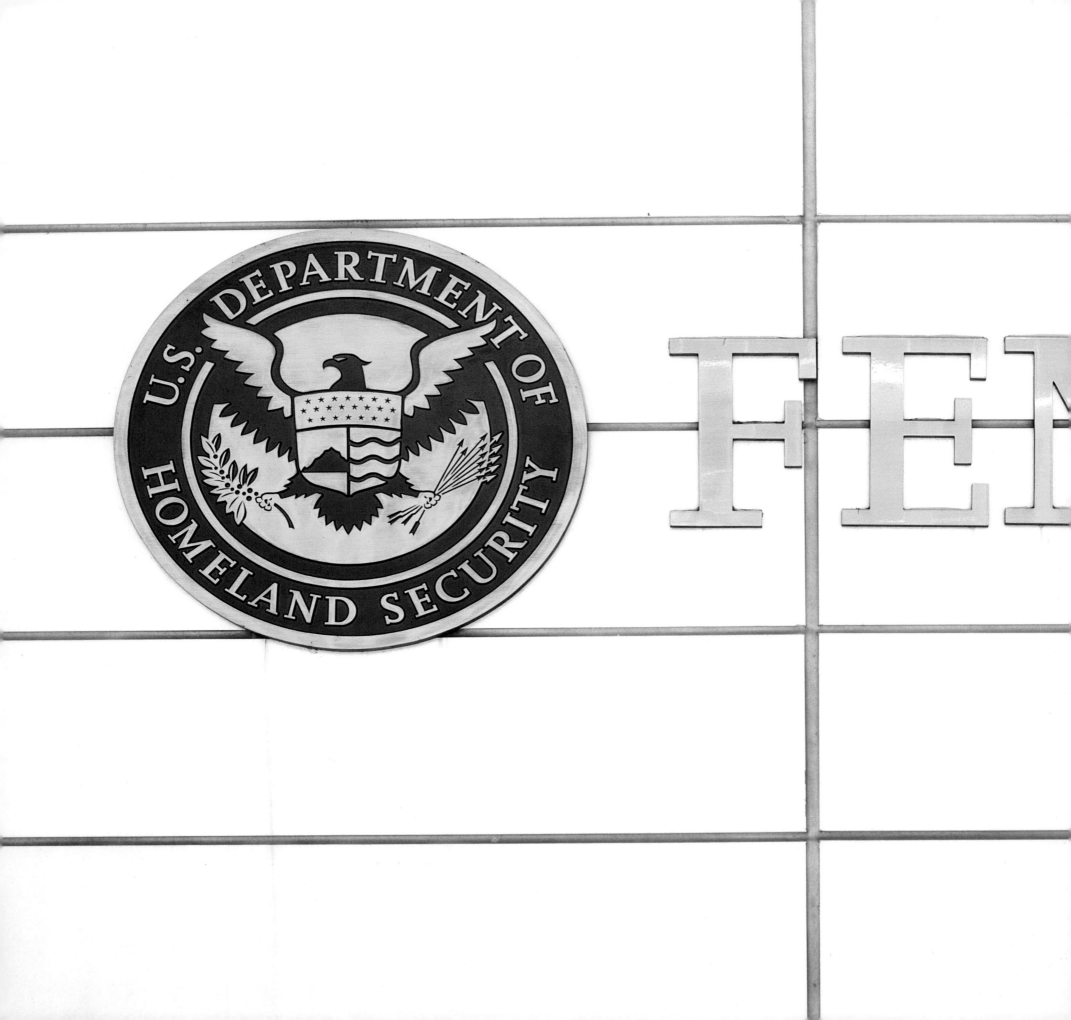

the First Gulf War. After the successful and relatively short campaign, a significant number of military personnel suffered from various ailments on their return, including, but not limited to, dizziness, extreme fatigue, insomnia and respiratory disorders.

These and other illnesses associated with military personnel serving in this campaign are collectively known as Gulf War Syndrome, as many doctors have been unable to effectively diagnose the causes of such varied symptoms. The US Department of Veterans Affairs has repeatedly fudged the issue and conspiracy theorists have a variety of explanations, ranging from aspartame, a synthetic sweetener used in soda drinks given to the troops on a regular basis, to the more sinister side-effects of chemical weapons.

FEMA

The United States' Federal Emergency Agency (FEMA) was set up by President Jimmy Carter (b. 1924) in April 1979 in order to co-ordinate and implement plans in the wake of a national disaster, or one that overwhelmed local resources. The initiative was in response to the nuclear emergency at Three Mile Island in Pennsylvania, which had occurred the previous month. Up until 2003, FEMA remained an independent agency, but, mainly in response to the 9/11 attacks, it was decided to bring it within the remit of the new Department for Homeland Security.

However, the poor preparation and badly co-ordinated response to Hurricane Katrina in 2005 highlighted the weaknesses in FEMA's ability to deal with natural disasters. The building of emergency camps by FEMA has now led conspiracy theorists to speculate that these are in fact concentration camps set up by Homeland Security for detaining dissidents and critics of the government, should it need to impose martial law as part of the New World Order.

Left: FEMA Headquarters in Washington, DC.

Economic Deceptions

The Peak Oil controversy has already been covered (*see* page 48), with suggestions both of regressive attitudes within the oil industry towards greener alternatives for energy consumption and also of the self-serving manipulation of prices and markets. The same rapaciousness can also be found in some pharmaceutical companies, whose focus is on profitability, often to the detriment of the consumer. Other economic deceptions include: the deliberate falsification of loss for insurance purposes; banks creating and selling inappropriate products to customers; and internet scams intended to prise money from unsuspecting, and often vulnerable, victims. Most of these rackets are eventually exposed and suitably prosecuted. One case, however, that will never be fully explained is the loss at sea of the 'unsinkable' RMS *Titanic*.

RMS Titanic

Robin Gardiner, in his 1998 book *Titanic: The Ship That Never Sank?*, alleges that *Titanic* never set sail from Southampton in April 1912 and that it was her sister ship. *Olympic*, launched in 1910 and looking almost identical to *Titanic*, had recently undergone repairs after a collision with a Royal Navy ship in September 1911, and was subsequently found to be at fault in the collision. Since the insurers, Lloyds of London, refused to pay the White Star Line, the owners of *Titanic* and *Olympic*, the two vessels were allegedly swapped. *Titanic* was already behind schedule, so the 'patched-up' *Olympic* was renamed *Titanic* and set sail. One of the most compelling pieces of evidence to support this theory was that *Titanic* had a slight list to the port side, a trait that would be consistent with the damage and repair to the *Olympic*. Others have since speculated that the ship's owner, the financier J.P. Morgan,

Right: The Titanic *(or was it the* Olympic*?) sank so rapidly there were few survivors.*

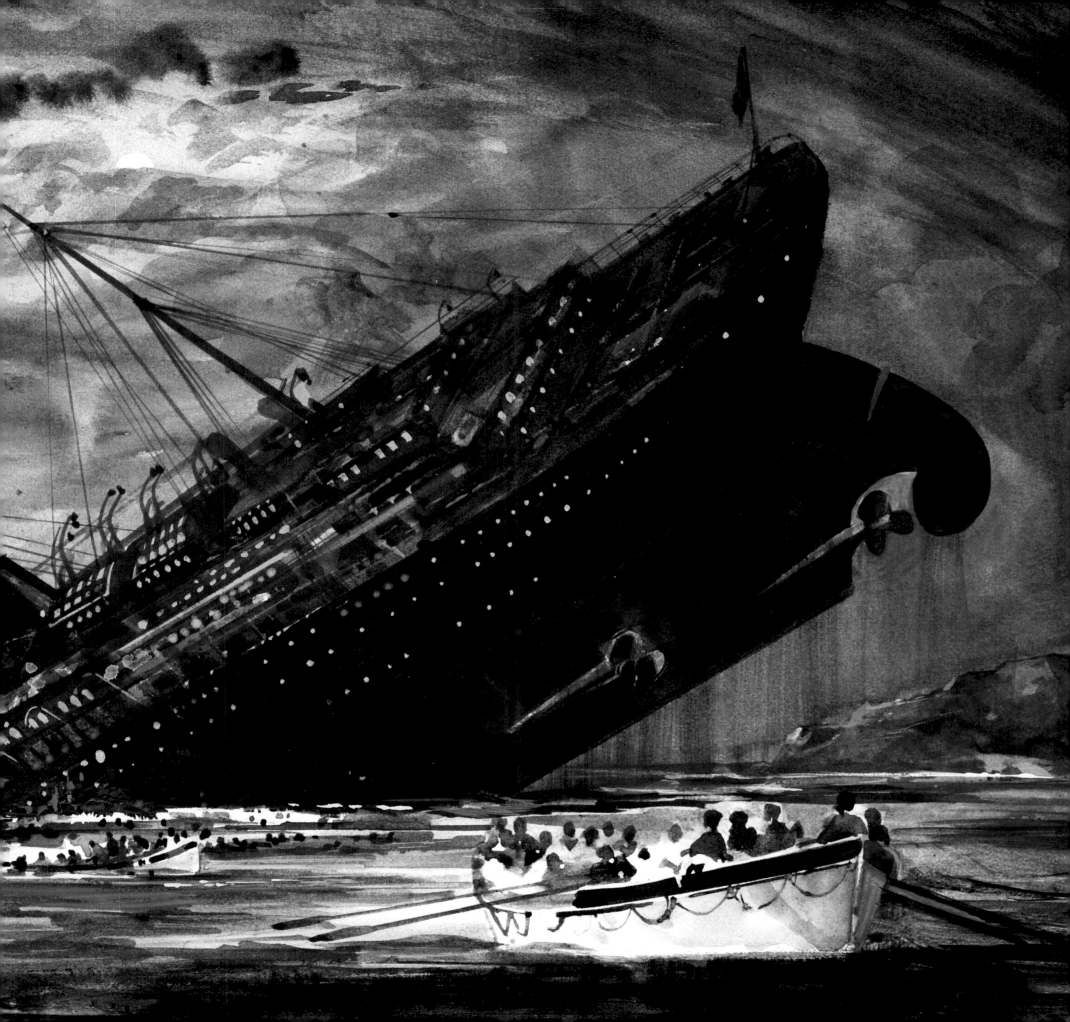

wanted to eliminate his main competitors in the banking world. At the time it was proposed by the US government to set up the Federal Reserve in order to stabilize the economy, something Morgan fully supported. Those opposed to it included John Jacob Astor IV (1864–1912) and Benjamin Guggenheim (1865–1912), both of whom perished in the disaster.

Big Pharma

The Big Pharma conspiracy theory contends that large pharmaceutical companies collude and conspire with the medical industry to deceive the public, putting profits before patients. The tag 'Big Pharma' came from a book called *Big Pharma: How the World's Biggest Drug Companies Control Illness*, written by the journalist Jacky Law and published in Britain in 2006, later in the US. The author focuses on why it is the pharmaceutical companies that dictate which healthcare issues are researched, rather than medical professionals or the concerns of the wider public.

Law initially focuses on the British pharmaceutical industry and the government's failures in regulation, as well as the extortionately high prices paid for drugs. She cites the industry's sophisticated marketing techniques and public relations exercises, rather than scientific excellence, to ensure it remains unchallenged in its strategies. She is also critical of both the medical profession and the government, who appear indifferent or even complicit in the methodologies used by pharmaceutical companies to win patents for new drugs. In addition, once the patent for a particular drug expires, many drug companies specifically obstruct the promotion of the generic, much cheaper alternative; a practice which, once again, the government appears to be indifferent to.

In *The Truth About The Drug Companies* (2005), author Marcia Angell, a doctor herself, also criticized drug companies, suggesting that many patented drugs are actually ineffective and use falsified test data to obtain their patents in the first place.

Left: The pharmaceutical industry is one of the largest, and certainly one of the most globally profitable (estimated at $600 billion), businesses, although some conspiracy theorists believe it to be unethical.

Terror on the Streets

The term 'terrorism' to describe the murder of innocent **people** and its subsequent effect of fear on the wider population was first used during the French Revolution at the end of the eighteenth century. It became more frequently used during the late twentieth century, with Britain labelling the Irish Republican Army (IRA) as terrorists following a number of bombings on the UK mainland from the 1970s on. There were also sporadic attacks worldwide by disaffected groups such as the Palestine Liberation Organization, the African National Congress (ANC) and Red Brigades. However, in the 1990s, these became more widespread, the attacks more audacious and with much deadlier outcomes. But is there more to them than just a wish to spread fear? Who is really behind these attacks?

Right: Did the US government plan the 9/11 attacks, to give them a pretext on which to invade Afghanistan?
Below: One World Trade Center, known as 'Freedom Tower' was built on the site of the former towers. In a sign of defiance, it is the sixth-tallest building in the world, its height of 1,776 feet (541 m) being a deliberate reference to the year when the United States Declaration of Independence was signed.

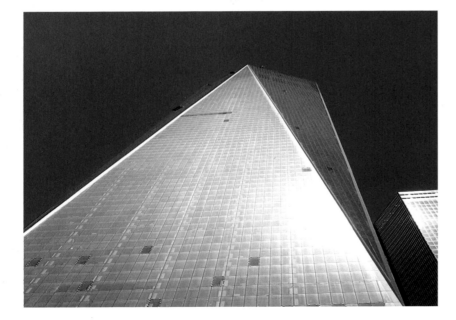

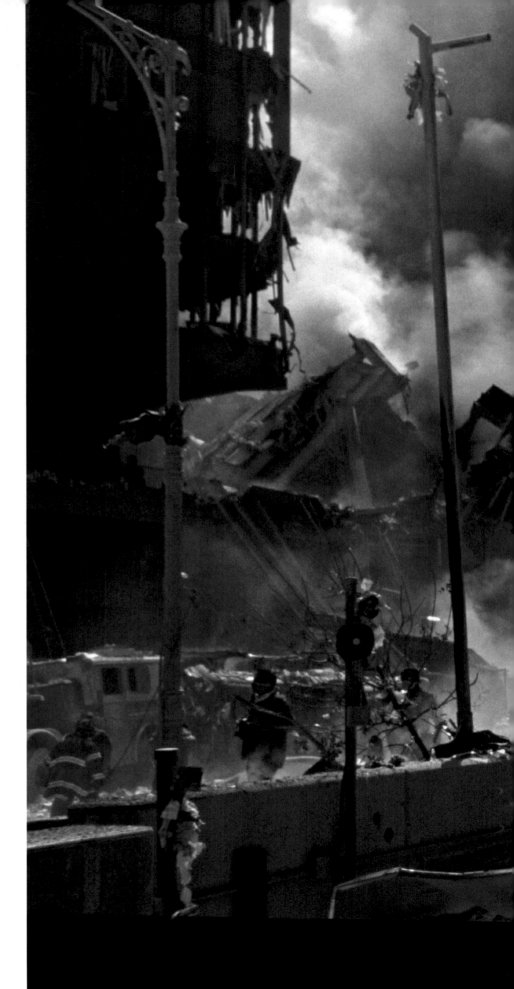

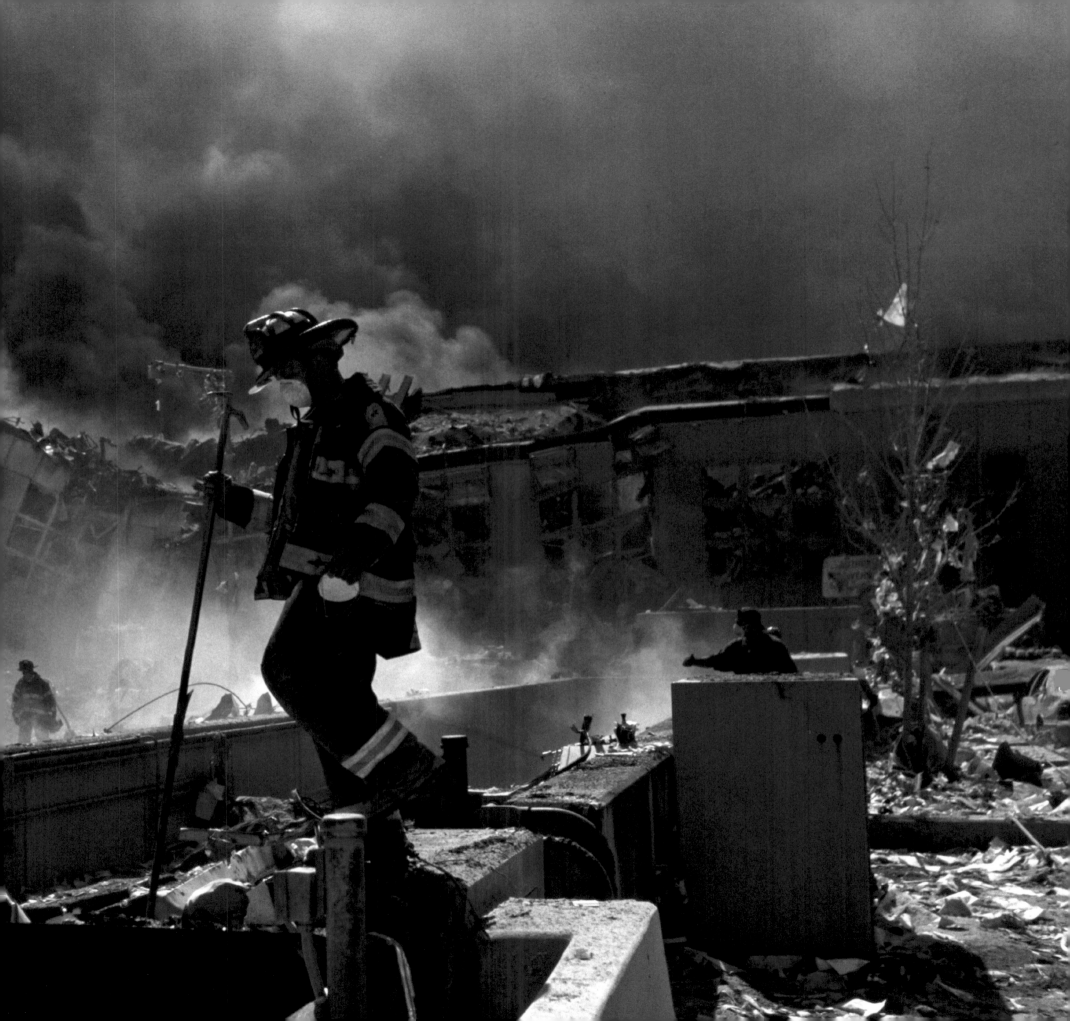

One of the most convoluted conspiracy theories surrounds the events of 11 September 2001, when four aircraft were hijacked and used as missiles to attack targets in the United States, killing nearly 3,000 people and injuring twice that many. In the aftermath, the US President George W. Bush declared a 'War on Terror', and persuaded Congress and the American people that he was justified in the invasion of Afghanistan, the alleged home of the perpetrators of the attack, Al-Qaeda.

The so-called 9/11 Truth Movement was established as a loose collective of conspiracy theorists who were sceptical of the government's investigations into the attack and the subsequent use of it as a pretext for war. Theorists want to know if the US government and/or its agencies had prior knowledge of these attacks and, if so, were they in any way complicit in them? The stand-down order given by the government to NORAD (North American Aerospace Defence Command) immediately following the first attack would suggest this is possible. Theorists are also concerned about a number of other discrepancies between official government statements about the events of 9/11 and the actual evidence.

London Bombings

Following the bombings on three London Underground trains and a bus on 7 July 2005, the Metropolitan Police issued CCTV footage of four British-born Muslims, who supposedly carried out the co-ordinated attacks that killed 52 people and injured hundreds more. The timings shown on the CCTV footage taken at Luton railway station, where the alleged attackers began their journey, does not, however, correspond to the timings of the actual bombings in London. Because of this and other anomalies, conspiracy theorists have suggested that the bombings were actually perpetrated as part of a government exercise to instigate anti-Muslim feelings, thus continually justifying the 'War on Terror'.

Left: Wreckage of the bus in Tavistock Square that claimed the lives of 14 people, including the suicide bomber on 7 July 2005.

Russian Apartment Bombings

In the late summer of 1999, four bombs were detonated in apartment blocks in three Russian cities, killing 293 and injuring over 1,000. The Prime Minister of the Russian Federation at the time was Vladimir Putin (b. 1952), who was praised for his handling of the crisis, particularly when a fifth bomb was discovered and defused in the city of Ryazan. Putin ordered the immediate bombing of the city of Grozny, the capital of the Chechen Republic, which was blamed for the attacks, and within a few months Putin became the country's president.

Since that time, several politicians who sought a public enquiry have died in mysterious circumstances, and the same fate befell several writers and journalists. One high-profile and widely reported death was that of Alexander Litvinenko (1962–2006), who was poisoned with the radioactive isotope polonium-210 while staying in London.

Many conspiracy theorists believe that the Federal Security Service (or FSB, Russia's security agency) were behind this murder, and that they may well have orchestrated the bombings at the behest of Putin, a former intelligence officer with the KGB in the Soviet era, in order to further his political ambitions.

Above: One of the apartment buildings that was destroyed in September 1999. Were they blown up deliberately to smooth would-be premier Vladimir Putin's path into office?
Right: Former KGB spy Alexander Litvinenko, who died after being poisoned by radioactive polonium-210 in November 2006; Russia has continually denied any involvement in his death.

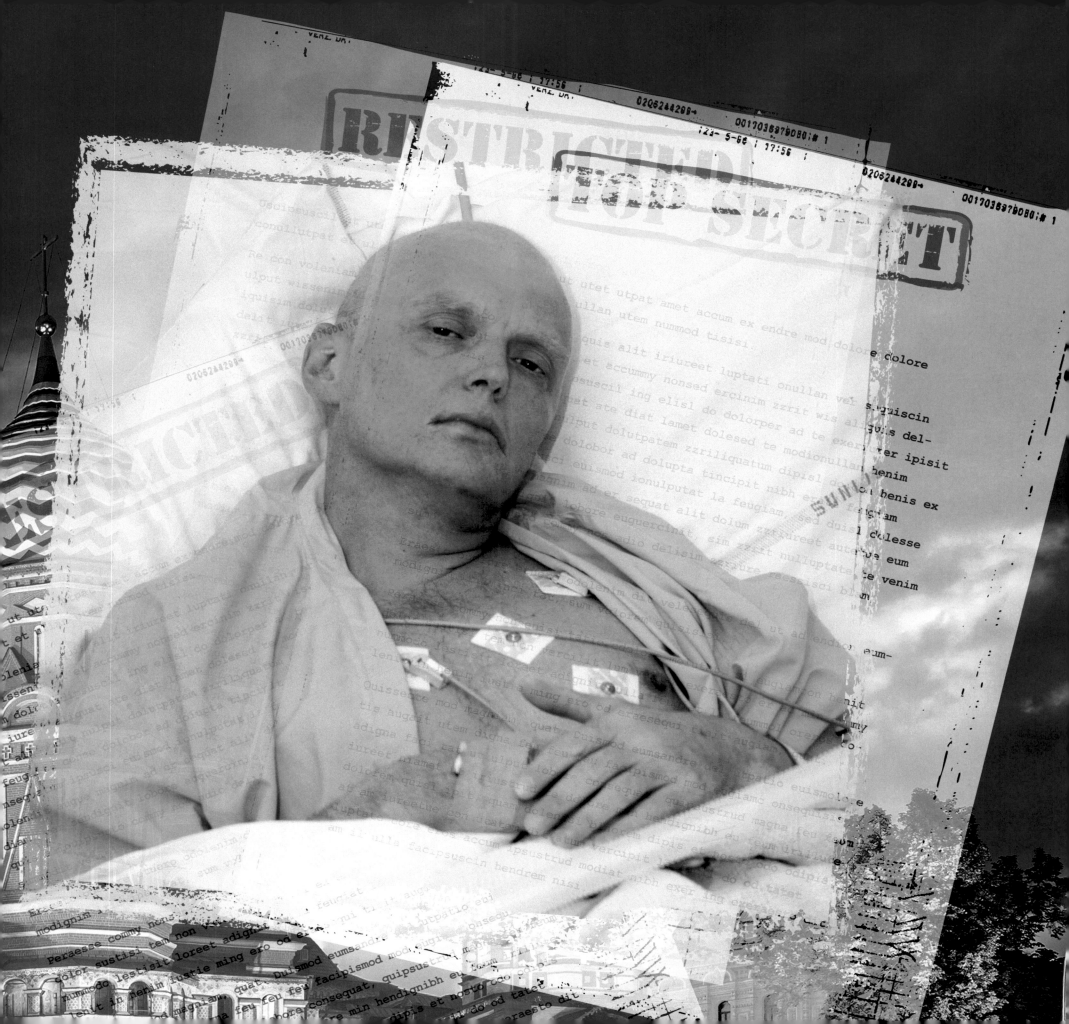

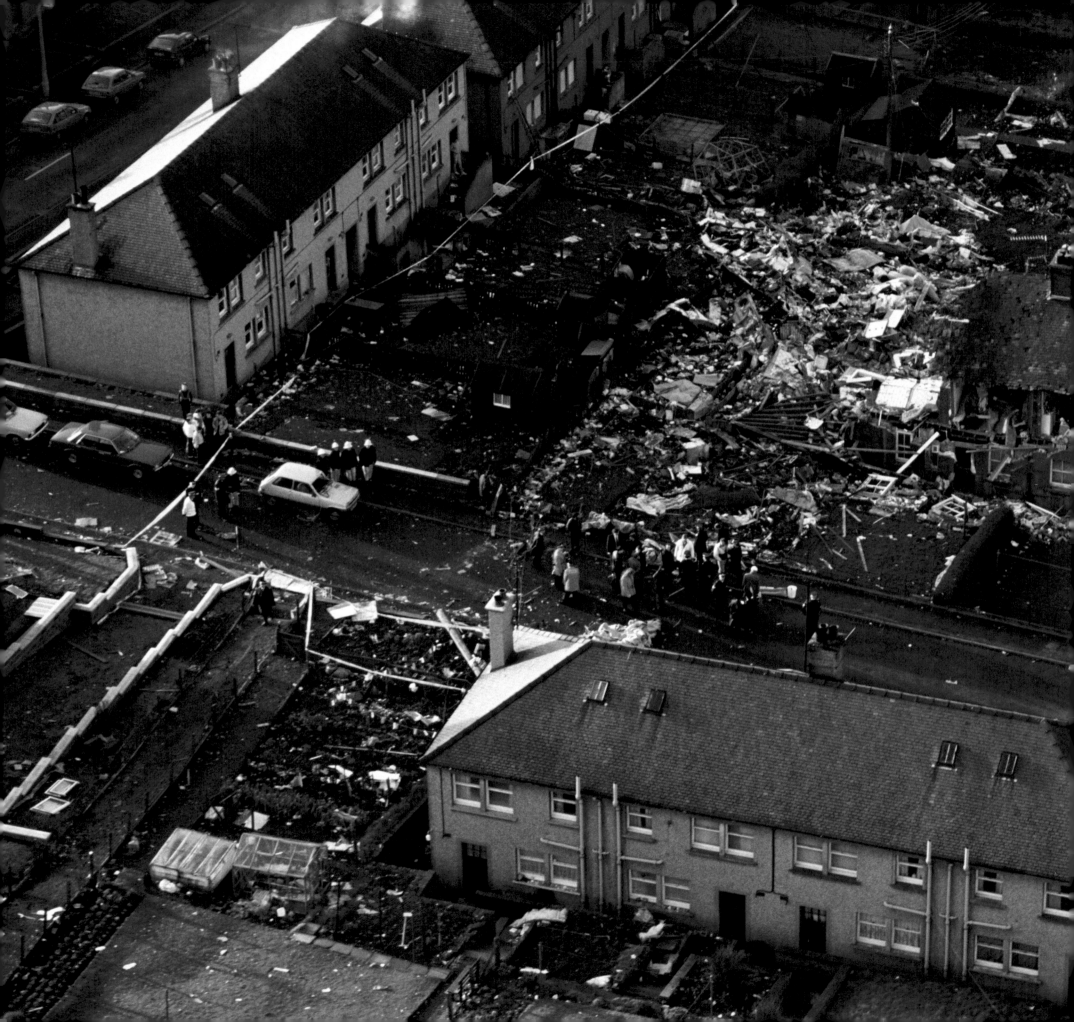

Aviation Mysteries

Fatal air crashes occur once in every 4.4 million flights, odds that are significantly lengthened to one in 16.5 million flights when it is due to a terrorist incident. When air crashes do happen, the press immediately begins to speculate about the cause as either a terrorist attack, human error or aircraft malfunction. Almost the first question to be asked is 'Was it an act of terrorism?' despite the statistical probability. When the evidence for the cause is inconclusive, conspiracy theorists love to piece the fragments of information together and compile their own theory as to the cause, sharing data online until they have a 'credible' account. Other theorists may speculate on whether a government was to blame for the crash.

The Lockerbie Bombing

In December 1988, a Pan American 747 aircraft exploded in mid-air, killing all 243 passengers and 16 crew. The aircraft wreckage landed on a small town

Left: Was there more to the Lockerbie plane bombing than a tragic air disaster?
Below: Wreckage of the 747 Pan Am airliner that exploded and crashed over Lockerbie, Scotland, 22 December 1988.

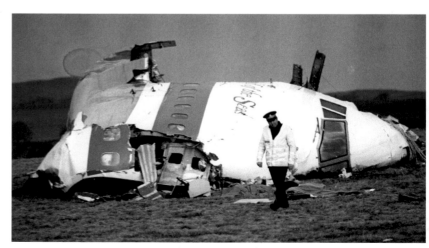

in Scotland called Lockerbie, killing another 11 people on the ground. It was discovered soon after the event that the plane had exploded due to a bomb being planted in its luggage hold. Eleven years later, the Libyan authorities handed over two men allegedly involved in the bombing to face trial in the Netherlands under Scottish law. One of them was found not guilty, and the other, Abdelbaset Ali Mohmed al-Megrahi (1952–2012), was found guilty and sentenced to life imprisonment. Many people, however, believe that he was a scapegoat for a deeper conspiracy.

One theory suggests it was an Iranian act of revenge for the shooting down of one of their civilian planes six months earlier, and that America and the UK conspired to point the finger at Libya for political reasons. Another less likely theory is that the route was usually used to transport illegal drugs by the CIA to its informants in the Middle East region in exchange for vital intelligence, and that a rogue operative swapped the drugs for explosives.

Flight MH370

A Malaysian Airlines flight disappeared from the radar on its route from Kuala Lumpur to Beijing in March 2014. Although some small fragments of the aircraft have been recovered, its bulk has yet to be discovered and the disappearance remains under investigation. Officially, the aircraft disappeared somewhere over the Indian Ocean, and yet none of its parts that would normally float and then be washed ashore have been found.

This has led to a number of conspiracy theories about its disappearance. One suggests that the aircraft landed on Diego Garcia, a US military base in the Indian Ocean, in order that the CIA could remove one of its passengers who was of interest to them. Others have suggested that it was

Right Malaysian Airlines Flight MH370 is reported missing on route from Kuala Lumpur to Beijing, March 2014.

达
Arrivals

02:10

计划	始发/经停站	预计	出口	状态
6:30	吉隆坡		B	延误
0:35	厦门	11:00	B	到达
0:40	首尔金浦	10:34	B	到达
1:10	香港	11:19	B	到达
1:20	大阪	11:36	B	到达
1:20	马尼拉	10:30	B	到达

划时间: 06:30 至 11:00

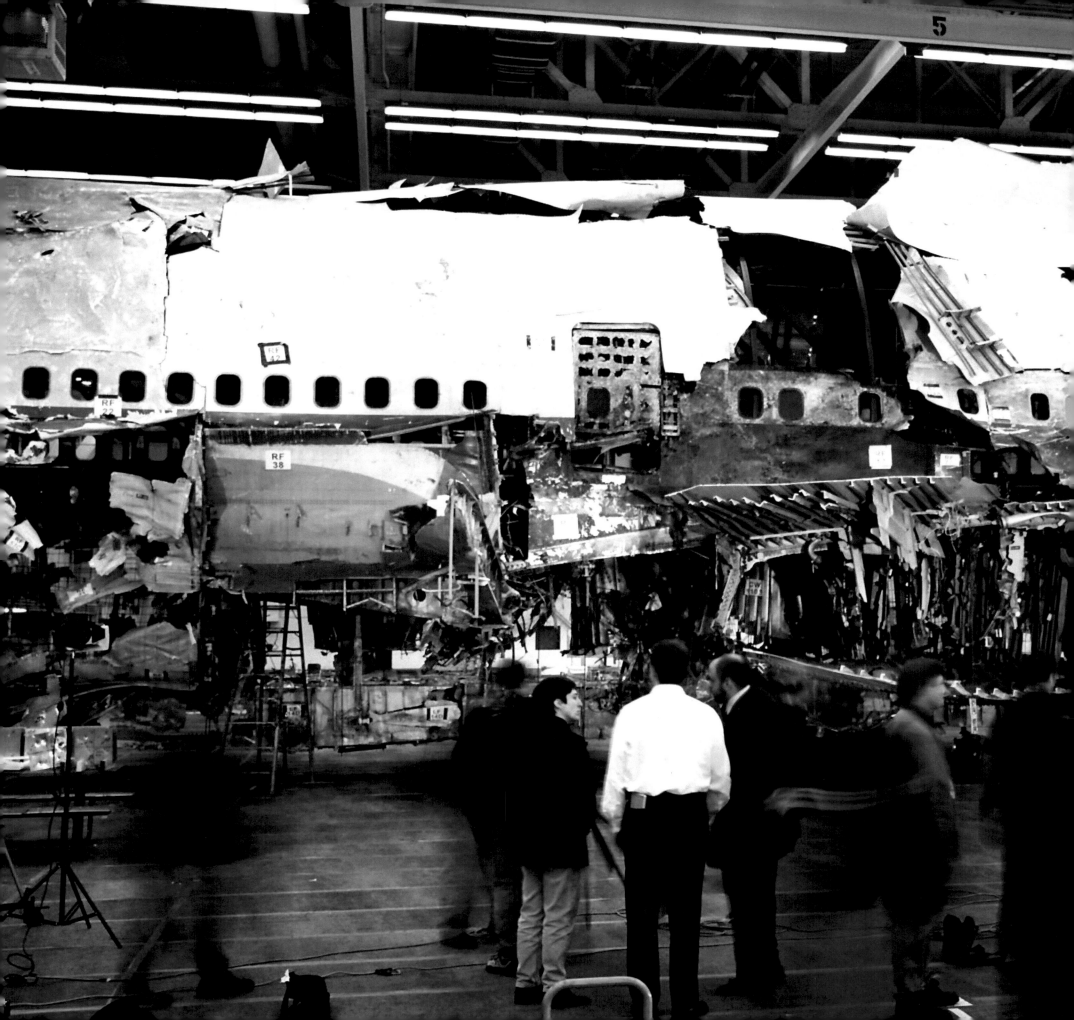

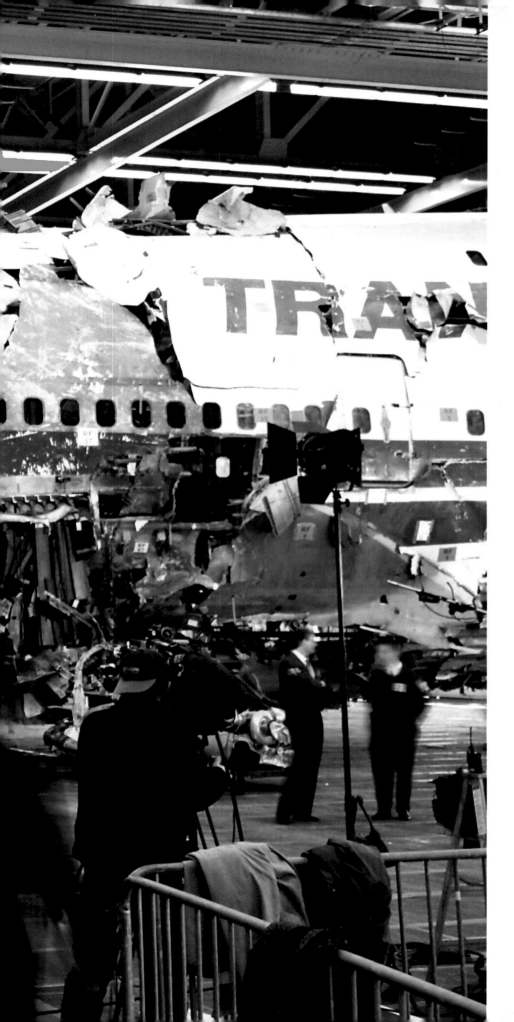

North Korea who hijacked the aircraft, or accidentally shot down the plane while testing missiles and covered it up.

Just four months later, in July 2014, another Malaysian Airlines aircraft, Flight MH17, was shot down over Ukraine by a Russian-made missile. The fact that this was the same model of aircraft – a Boeing 777 – as Flight MH370 has led to some speculating that this was more than just coincidence, and that the two flights were, in fact, the same plane.

Whatever happened to the flight, its fate remains unknown, with no resolution to the mystery in sight.

TWA Flight 800

In 2013, 17 years after the event, a documentary was made concerning the unsolved mystery of TWA flight 800, which exploded shortly after take-off from John F. Kennedy Airport, New York in July 1996. After an investigation by the National Transport Safety Board (NTSB) that lasted for nearly four years, it was concluded that the probable cause of the explosion was a faulty fuel tank. In a separate investigation, the FBI closed their file after finding no criminal activity involved in the explosion.

However, some of the original investigators were not satisfied with these conclusions and requested the case to be reopened. Many now believe that it was a 'friendly-fire' missile that struck the aircraft and the government is covering this up. A book was published in 1997 outlining this theory, based mainly on eyewitness testimony, which the NTSB considered irrelevant because of the variance in what people actually saw. This, of course, has only added to the mystery that continues to surround this event.

Left: *The main fuselage section of TWA flight 800 being examined by forensic experts to determine the cause of its crash shortly after take-off in New York. Was it a friendly-fire incident?*

Leaders of
the World

The conspiracies explored here are primarily concerned with Western leaders, but some of these suspicions are likely to arise anywhere in the world. Saudi Arabia, for example, is known as the most corrupt country in the world, because of its huge oil wealth and complex negotiations with Western states over arms sales. Some theorists argue that globalization has made such corruption not only possible but also increasingly common among many of the world's leaders. Many theorists believe that these leaders are part of the New World Order, in which absolute power is held within the hands of a small minority.

Bush, Blair and WMDs

In March 2003, US President George W. Bush announced that coalition troops had invaded Iraq to disarm the country of weapons of mass destruction (WMDs). British Prime Minister Tony Blair issued a similar statement to the effect that intelligence sources had led him to declare that Iraq had WMDs, and that Britain would be a major part of the coalition. Both countries stated they were acting in defence of their respective states. Despite the British Parliament and US Congress passing the necessary legislation to declare war, many conspiracy theorists have claimed that the invasion was illegal, and that it was conducted to secure Iraq's oil, as consumption requires the US to import 60 per cent of its needs.

Conspiracy theorists believe that President George W. Bush (son of the former president who initiated the First Gulf War) and Vice-President Dick Cheney

Right: Anti-war protesters take to the streets in London, September 2003.

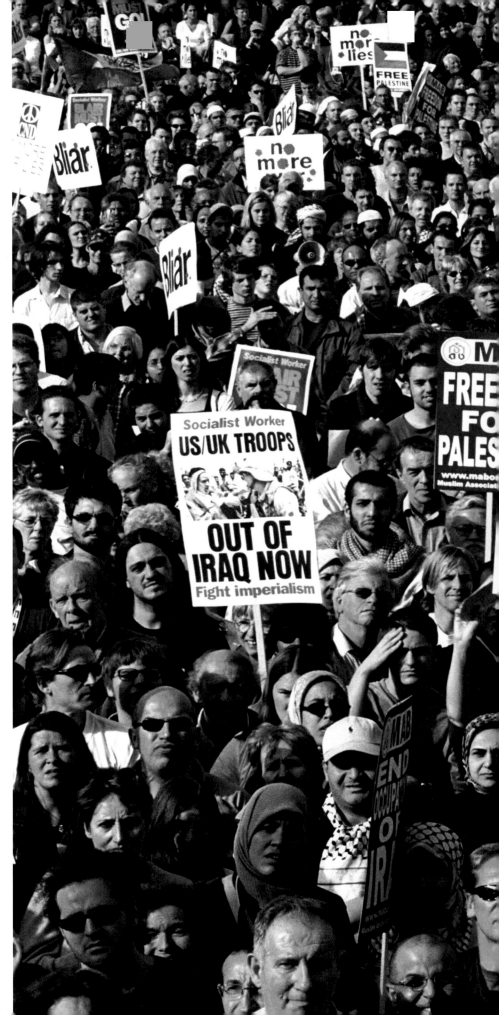

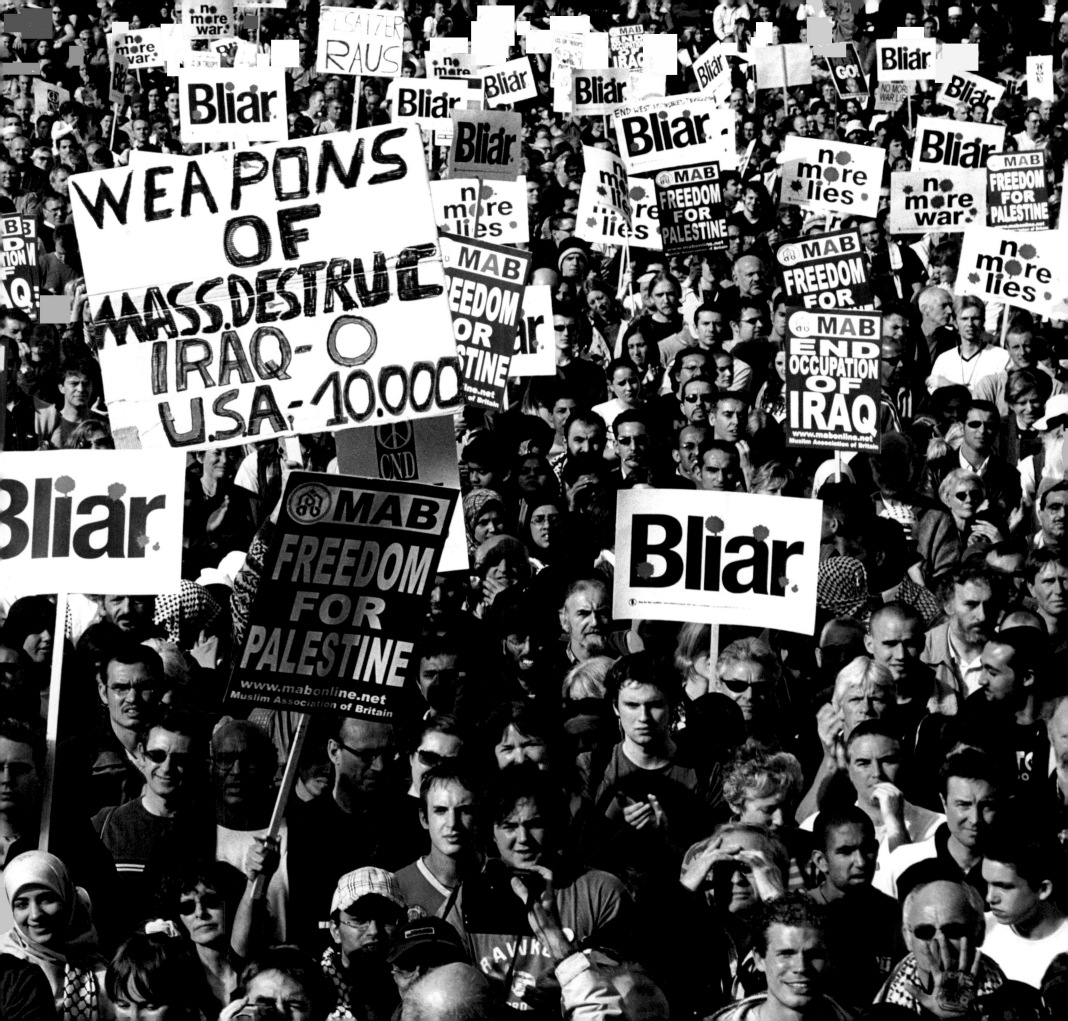

(b. 1941), both of whom had business interests in the oil industry, deliberately manipulated the concept of WMDs in order to justify an invasion of Iraq. The theorists also suggest that Iraq had been a target for the US since 1992 and needed an excuse for invasion. The 9/11 attacks provided a justifiable excuse, since it was widely circulated that Iraq's leader Saddam Hussein harboured terrorists with links to Al-Qaeda. Theorist's attention has been drawn to the setting up of an Office of Special Plans (OSP) at the Pentagon within months of the 9/11 attacks, specifically to plan and co-ordinate the invasion. This was instigated by Secretary of Defence Donald Rumsfeld (b. 1932) as a tool for garnering raw intelligence material on Iraq that could subsequently be manipulated.

Barack Obama

The 44th President of the United States, Barack Obama (b. 1961), has been the subject of conspiracy theories since his first campaign for the Senate in 2004. Some allege that, despite his Christian credentials, he is a practising Muslim in private, a factor that would probably have impeded his political ambitions. In a poll conducted in 2012, at the end of his first term in office, about one third of conservative Americans believed this to be true. Obama regularly attended Christian worship, but the theorists have based their ideas on his estranged father Barack Snr (1936–82), who was considered an atheist and possibly even sympathetic to Islam. Barack Jnr was also seen as being sympathetic to Islam when, as President, he called for a 'new beginning between the United States and Muslims', a comment that alienated many conservatives. One of Obama's main critics in this regard is the conservative talk show host Michael Savage (b. 1942), who has also labelled him a Marxist and a 'foreign usurper'. This last remark is based on ideas about Obama's place of birth, since all presidential candidates have to have been born in the US. Obama was born in Hawaii, but spent some of his early years in Indonesia, where his mother remarried Lolo Soetoro Mangunharjo (1935–87), another follower of the Muslim faith.

Left: Former US president, Barack Obama.

In a broader context, some theorists see Obama as a puppet president, in much the same way as they have viewed all American presidents since John F. Kennedy, as part of the New World Order conspiracy. Of particular note are the numerous U-turns Obama made as president compared to his election promises. For example, he pledged to keep lobbyists and donors out of his administration if elected, a promise on which he reneged, further suggesting that the 'elite' were really in control of central government.

The Deep State

In his farewell speech to the nation in January 1961, outgoing US President Dwight D. Eisenhower (1890–1969) voiced his concerns about what he called the military-industrial complex – the collaboration between arms manufacturers and the military, without necessarily gaining government approval – that had gone on since the Second World War. Such a co-ordinated approach to US policy without regard to those who are democratically elected is what has become known to conspiracy theorists as Deep State, a term now used to include the judiciary and intelligence services as well as the military. The academic Dr Alfred McCoy (b. 1945) has suggested that since 9/11 the intelligence services have created a fourth branch of the US government that is 'autonomous from the executive, and increasingly so'.

Above: *Dwight D. Eisenhower warned of the potential danger of the Military-Industrial Complex in 1961; perhaps his worst fears are now being realized?*
Right: *Who is really in control at The White House?*

Ancient Mysteries

Lost Civilizations

Who built Stonehenge and why? What happened to the civilization that built it? This 5,000-year-old monument has baffled archaeologists and anthropologists for centuries, and we are no nearer to uncovering these mysteries because of the lack of written evidence. Archaeologists have uncovered many artefacts that have led to a number of theories, but the lack of anthropological evidence has encouraged theorists to develop a number of hypotheses, including the possibility that these people were part of an extraterrestrial settlement and culture. There are many such ancient sites around the world that also raises the question: 'What happened to this civilization?'

Previous page, left and below: Did giants help construct Stonehenge, as described in the medieval chronicle The Brut, *or perhaps it was aliens? We will never know.*

Stonehenge

Archaeologists have established that the first construction at the site was built about 3000 BC, probably in three different stages and completed approximately 1,000 years later. Artefacts found near the site suggest that it was occupied by human hunter-gatherers, but were they its builders? Such gaps in our knowledge about Stonehenge have ensured that the conspiracy theorists are kept busy. One theory, based on a twelfth-century text called *The Brut*, is that giant figures called Nephilim built it. Another is, of course, that aliens built it, along with many other ancient monuments. In an effort to map the various monuments globally, the so-called 'World Grid' has been developed, which links all the sites and creates a crystal-shaped diagram that theorists believe was the original intention of the extraterrestrials. It was the pioneer archaeo-astronomer Sir Norman Lockyer (1836–1920) who first identified the geometry connecting the alignments of ancient sites.

The Mayan Civilization

There is sufficient evidence to show that the Mayan civilization is at least 3,000 years old but its so-called 'Classic period' was between 200 and 900 AD. After the thirteenth century it seemed to mysteriously die out. The Mayans were a Meso-American civilization that lived predominantly in what is now southern Mexico. The most significant ancient cities that have evidence of their existence are Copán, Palenque and Chichén Itzá. The evidence for the abandonment of the sites is the lack of continuous hieroglyphic inscriptions after this period.

Although most scientists have suggested their demise is probably due to either climate change, famine or disease, many theorists believe it is linked to an ancient astronomical theory and its rulers returned to an unknown

Right: The Kukulkán pyramid at Chichén Itzá features sophisticated astronomical references, including the number of steps on each of the four staircases equalling the number of days between each of the four equinoxes.

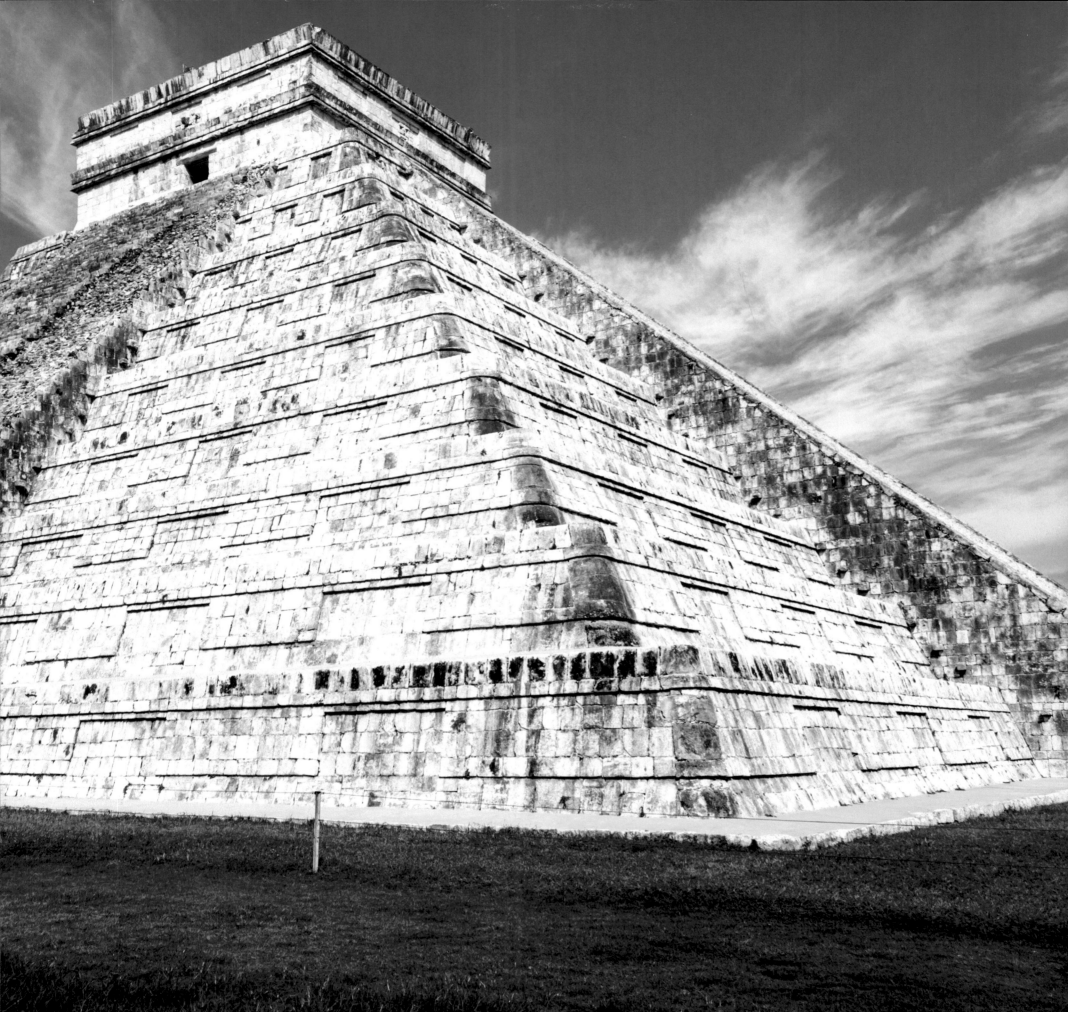

destination in outer space. One of the most compelling pieces of evidence is the tomb inscription of King Pakal (603–683 AD) at Palenque that, according to Erich von Däniken, depicts him on the inside of a spacecraft operating various controls. Other evidence is from engravings on a staircase at Copán showing Mayan priests in communication with gods, whom theorists believe are in fact extraterrestrials.

Nazca Lines

The Nazca culture flourished between 100 BC and 800 AD on the coast of southern Peru, and was renowned for its multicoloured pottery and complex textile designs that often included anthropomorphic figures. One of the most intriguing aspects of their design legacy is a series of large geoglyphs, known as the Nazca Lines. There are literally miles of lines carved into the surface of the desert plateau, many representing zoological figures such as birds and monkeys, some of which cover an acre of ground each. Best viewed at high altitude, many theorists have suggested that they were created to be seen by their gods (or 'ancient astronauts'), rather than by humans on the Earth's surface.

Lascaux Caves

In 1940, an 18-year-old entered a cave at Lascaux, in the Dordogne region of France, looking for his missing dog. As he went deeper into the cave, he discovered a large number of prehistoric paintings on the walls dating from about 15,000 BC. The images are mostly of herbivorous animals such as cattle, the only depiction of humans being handprints. The reason for these paintings remains a mystery. Since there is no indication of human habitation within the caves on a permanent basis, it is assumed they were not for decorative purposes, rather as offerings to the gods or used as part of a ritual attended by humans.

Left: The Nazca Lines depict a number of identifiable animal species, including this condor, an important symbol of Peruvian folklore and culture, whose bones are believed to contain medicinal powers.
Next page: Panel of the Unicorn, Lascaux caves, France. Why were the paintings created, and by whom?
Next page small image: Ancient human hand prints from caves in Patagonia.

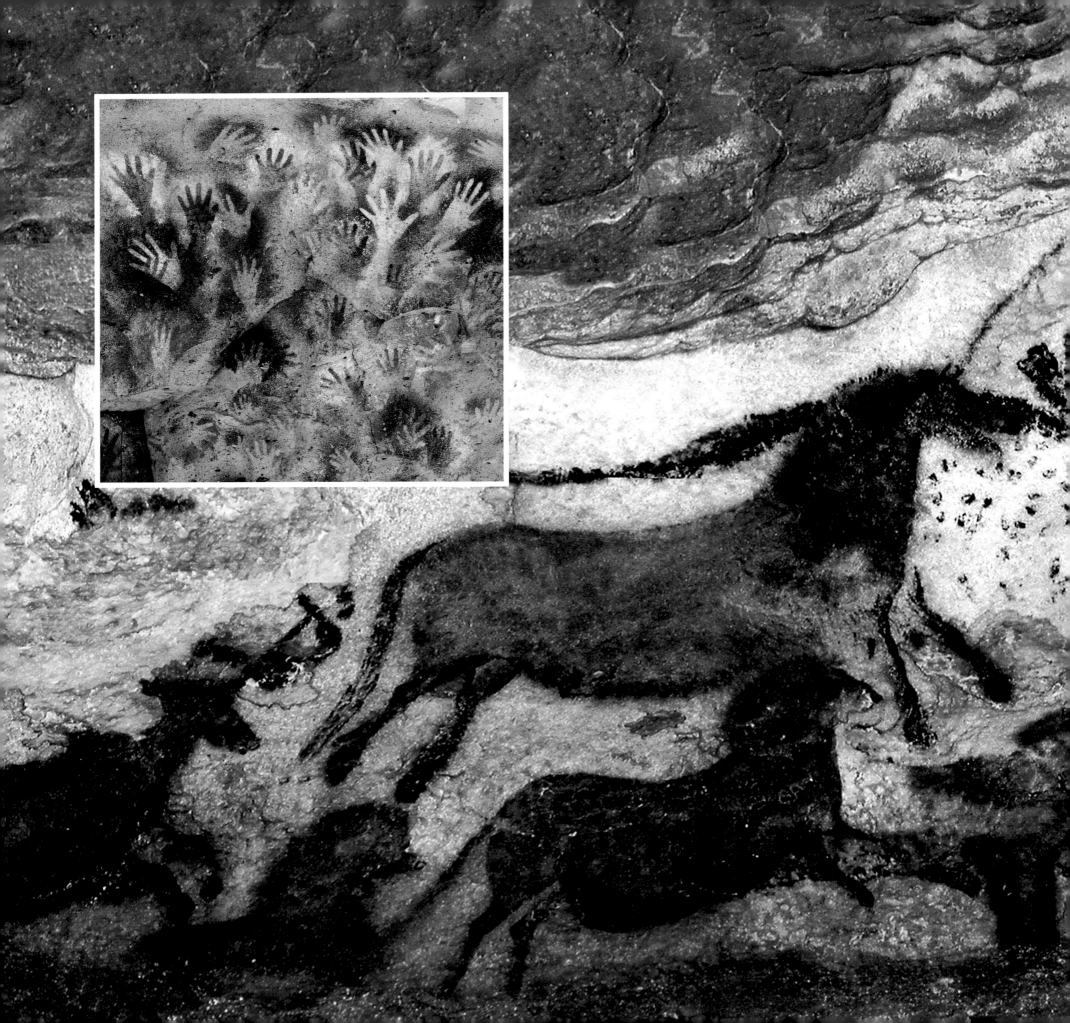

Lost Cities

It seems highly improbable that an entire city can just disappear without trace and yet, at the turn of the twentieth and twenty-first centuries, the lost cities of Thonis-Heracleion and Canopus were discovered in the Nile Delta, buried in the shifting sands for over a thousand years. The discoveries by underwater archaeologists of buildings, ships and huge statues enabled anthropologists to reassess the important trading links between Greece and Egypt at the time of the last pharaohs 2,000 years ago. It is therefore quite possible in years to come we will at last be able to uncover the mysteries of other lost cities, such as Atlantis.

Right: Little did we know what secrets the Nile Delta was hiding beneath its tranquil waters.
Below: Dating from 380 BC, this granite stele was recovered from the sunken city of Thonis-Heracleion in the Nile Delta. How many other civilizations have been lost in this way?

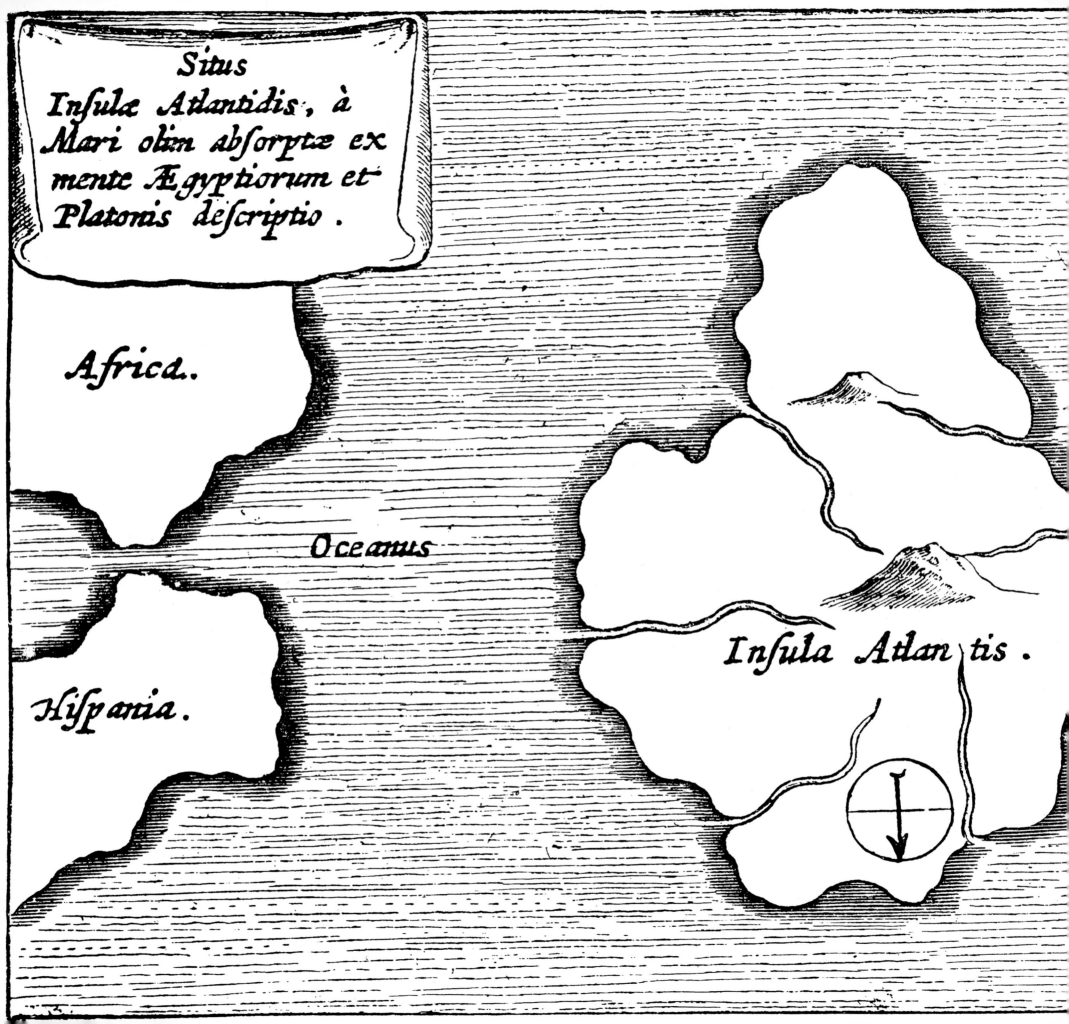

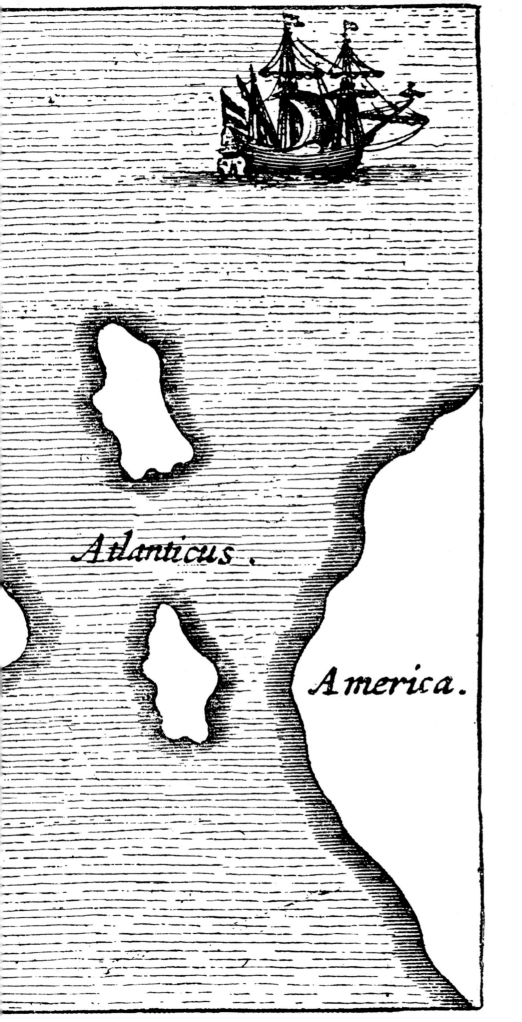

Atlantis

In the fourth century AD, the writer and philosopher Plato (*c.* 428–348 BC) wrote about the fictional island of Atlantis and its disappearance 9,000 years before as an allegory on the hubris of mankind. As such, the place had a minor role in his discourse, but in modern times people have speculated that, although the name Atlantis may be fictional, there could actually be a 'lost' city state that served as Plato's inspiration. Such speculation began in the sixteenth century, at a time when the New World was being discovered and the Spanish had discovered the remnants of the mysterious Mayan and Aztec cultures. Writers such as Thomas More (1478–1535) used the fictional Atlantis and the discovery of Meso-American civilizations as the basis for his book *Utopia*, published in 1516. Others such as Ignatius Donnelly (1831–1901) speculated that the island was real and destroyed in the Great Flood, as described in the Book of Genesis.

The Lost Continent of Mu

Based on his findings and interpretations of Mayan culture in Meso-America, the French-American writer and amateur archaeologist Augustus Le Plongeon (1826–1908) speculated that there was an entire lost continent in the Atlantic Ocean called Mu. Another writer, James Churchward (1851–1936), expanded this idea and suggested that in fact Mu was originally in the Pacific. Although both accounts have subsequently been dismissed as pseudoscience, professor of marine biology Masaaki Kimura (b. 1940) has given credibility to the idea of the lost continent by suggesting that monuments found off the coast of Japan at Yonaguni Island in the 1980s belonged to the Mu civilization.

Left: The island of Atlantis was first described by Plato and was said to lie just beyond the Pillars of Hercules (Gibraltar and Mount Hacho). Could it be a real place, now lost to the world?

Above: The submersion of Mu, the 'lost' Pacific continent, by flood and volcano.

The Lost Continent of Lemuria

The idea of a lost continent in the Indian Ocean was first mooted by the zoologist Philip Sclater (1829–1913), due to similarities of flora and fauna found in India and on the African island of Madagascar. He postulated that in fact India and Madagascar had at one time been joined, based on remains of a species of lemur discovered at both places but not to be found either in mainland Africa or other countries adjoining India. Plate tectonic science, developed in the 1960s, has largely disproved this, but more recently evidence has been discovered of a large land mass about three times the size of Japan, called the Keruelen Plateau and submerged beneath the Indian Ocean.

Right: A nineteenth-century artist's impression of the lost continent of Lemuria, suggesting that it was home to a highly developed and technologically advanced civilization, approximately 12,000 years ago.

OOO YEARS AGO The most fascinating legend of man is the legend of the lost continent of Lemuria. It is the firm belief authorities and archaeologists, that approximately 12,000 years ago, a great civilization flourished cific, mother country of many colonies all over the globe, among them Yucatan, Egypt, Babylon, y others. All of today's civilizations are supposed to be the results of Lemurian colonization. (For complete details, see page 144.)

Mysterious Beasts

However improbable monsters and mysterious beasts are, they have always been a feature of folklore in various parts of the world. The Irish have leprechauns, the Chinese have dragons, while the ancient Greeks had the minotaur. Despite scientific advances, many cryptozoologists still believe in the existence of strange creatures, and seek to provide scientific evidence such as photographs whenever possible. Conversely, there are the sceptics such as the palaeontologist George Simpson (1902–84), who stated: 'Humans are the most inventive, deceptive and gullible of all animals.'

The Loch Ness Monster

The first use of the term 'monster' to describe a mysterious sighting at Loch Ness in Scotland was in 1933, appearing in a local newspaper article. However, the first chronicled sighting was in 565 AD by the Irish monk St Columba (521–597), who had witnessed the burial of a man supposedly attacked by a sea monster that resembled a dragon. Since 1933, there have been numerous sightings and photographs taken of the alleged monster, most notably the famous 'surgeon's photo' of 1934 that appeared in the *Daily Mail* national newspaper. Some 50 years later it was shown to be a hoax, along with several other images. However, the mystery continues, and this is despite several scientific investigations using modern technology having failed to find the monster, now affectionately called 'Nessie'. Scientists have, however, tried to explain the sightings as a non-native animal species that found its way into the loch by river; candidates have included the Greenland shark, or a long-necked salamander.

Left: One of the earliest serious attempts to find the Loch Ness Monster was in 1934, an expedition led by Sir Edward Mountain (1872–1948) that resulted in this photograph.

The Beast of Bodmin

In 1993, a video was made of a large black cat prowling the moor at Bodmin, in Cornwall, England. In the late 1970s, there had been numerous sightings of the 'cat' at a time when a number of domestic animals had been killed and their bodies mutilated. It was subsequently discovered that the animal trainer Mary Chipperfield (1938–2014) had released three pumas into the wild at Bodmin after her own zoo was forced to close. (Chipperfield was later found guilty of animal cruelty in a different case in 1999).

As late as 1995, the government agency responsible for an investigation into the 'Beast' concluded that there was no verifiable evidence of a large feline species capable of causing livestock deaths on Bodmin Moor. A week after the report was published, a young boy walking on the Moor discovered a skull which turned out to be that of a leopard.

Yeti, The Abominable Snowman

The Yeti is a mythological creature, enshrined in Nepalese and Tibetan folklore, that resembles an ape-like creature considerably taller than a human. The Abominable Snowman is a Western interpretation of that legend as encountered during an expedition to climb Mount Everest in the Himalayan Mountains in 1921. The leader of the expedition, Charles Howard-Bury (1883–1963), recalled seeing large footprints in the snow at 6,400 metres (21,000 feet) that he referred to as those of a 'loping wolf'. His accompanying Sherpa advised him that they were 'metch kangmi', which translates as 'filthy snowman', later transcribed as the 'Abominable Snowman'.

In subsequent expeditions to climb Everest, most notably in 1953 by Sir Edmund Hilary (1919–2008) and Sherpa Tensing (1914–86), many have seen large footprints, which cannot be identified from the photographs taken.

Right: Could this be the Beast of Bodmin?

A number of subsequent sightings of a mysterious biped have been reported, and there have also been hair samples taken from these sites, whose DNA does not match a known animal species.

The Mothman

In 1966, a small group of men were working in a cemetery at Clendenin, West Virginia, USA, when they witnessed a human figure with wings fly from a tree and pass overhead. This was the first of several sightings over the course of a year of a mysterious flying creature in this area and at nearby locations, most notably at Point Pleasant. The figure was described similarly by all, with some of them claiming the creature had red eyes. The sightings ended in December 1967 with the collapse of the Silver Bridge at Point Pleasant, which killed 46 people. A later investigation as to the cause of the collapse concluded that it was a weakness in the bridge's construction, but some have speculated that it was the work of the Mothman. Inevitably, these sightings have been the subject of conspiracy theorists, who maintain that the Mothman was in fact an extraterrestrial that wreaked havoc in West Virginia, culminating in the deaths of some of its citizens.

Above: An alleged photo of Bigfoot; at 2.3 m (7½ ft) tall, this is the American version of the Abominable Snowman.
Left: In 1951, Eric Shipton (1907–77) led a British team in what became the preliminary expedition for Sir Edmund Hillary's conquest of Mount Everest, where he took this photograph of unidentified footprints.

Religious Conspiracies

Religious conspiracies are founded on the premise that one religious group persecutes another over the authenticity of their creed. The persecution of the Jewish people dates all the way back to Ancient Greece; Christians have crusaded against Muslim nations and the Ottoman Empire oppressed Christian citizens; following the Reformation, Protestant Christians were pitted against their Catholic counterparts; and today many agnostics and atheists claim that all religion is a scourge on humanity, since it seeks to control and manipulate society for malevolent ends. Those who believe in the New World Order theory speculate that all religious divisiveness will be neutralized, or even eliminated, in order to maintain social control.

The Knights Templar

The Knights Templar was a religious military order founded in 1129, sanctioned by the Pope, that saw active service during the Crusades in the Holy Land. The Knights Templar was established primarily to protect pilgrims making their way to Jerusalem, and their members became the most feared and respected knights in the Holy Land. It was, however, only about one quarter of the order that were used in this way. The remaining knights established themselves as bankers, becoming very wealthy in the process. Their rise to power threatened the ruling class and the order was dismantled under Papal authority in 1312. Pope Clement V (1264–1314) had established the Papal court in Avignon, France, and was heavily influenced by the French King Philip IV (1268–1314), who was suspicious of the order's activities and aspirations. He was also heavily in debt to them.

Right: The Knights Templar founded this convent in Tomar, Portugal, in the twelfth century; its adjacent castle and town became one of their strongholds until they were disbanded in the fourteenth century.

Above: *Twelfth-century fresco in the Chapel of Templars, Cressac sur Charente, France, depicting a Templar knight during the Battle of al-Buqaia, Lebanon, in 1163, against Nur ad-Din.*
Left: *The window of the Rosslyn Chapel, Scotland; according to* The Da Vinci Code, *the chapel is the possible resting place of the Holy Grail.*

On Friday 13 October 1307, large numbers of Knights Templar were arrested and burned at the stake. (This date is often cited as the beginning of the superstitions around Friday the 13th.) The Pope subsequently gave orders to all heads of Christian states that Knights Templar should be arrested. Many of them were tortured into confessing to heresy and burned at the stake, but a good many escaped into obscurity. It is believed by theorists that, while in Jerusalem, they found the Holy Grail and the Ark of the Covenant, which were subsequently hidden by the Knights Templar.

Although the last Grand Master of the original Knights Templar order was executed in 1314, numerous reincarnations of the medieval organization are still in existence today. The best-known of these – thanks to Dan Brown's (b. 1964) *The Da Vinci Code* (2003) – are the Freemasons (*see* page 63), who have adopted many of the symbols and rituals of the original order. Whether present-day members of these organizations really are guardians of secret knowledge is highly unlikely, but mystery and intrigue continues to swirl around both them and sites associated with this ancient order.

Protocols of the Elders of Zion

Widely seen as influencing other later conspiracy theories, *The Protocols of the Elders of Zion* was first published in Russia in 1901. It is an avowedly anti-Semitic document whose publication coincided with the expulsion and murder of Jews during harsh Russian pogroms in the late nineteenth century. *The Protocols* are a fictional account of a meeting between the Jewish elders, in which they discuss world domination by bankers and press barons. The text was later disseminated and distributed as a factual document, the car maker and anti-Semite Henry Ford (1863–1947) funding the printing and distribution of half a million copies in the US. Although it was shown to be a fabrication by the *Times* newspaper in 1921, it remained in use as anti-Semitic propaganda and was referred to by Adolf Hitler (1889–1945) in his book *Mein Kampf*, published in 1925. *The Protocols* was widely used in the classrooms of Germany as a statement of fact, and widely disseminated as a justification for the 'Final Solution'.

Although the text is rarely referred to in Europe, it is still disseminated in the Arab world, by Hamas and other anti-Zionist organizations.

Above: *Published in the early twentieth century,* The Protocols of the Elders of Zion *purportedly describes how a secret brotherhood seeks world domination.*
Right: The Protocols *was used as anti-Jewish propaganda by the Nazi Party.*

Die Geheimnisse der Weisen von Zion

„Alles dieses wußte ich schon vor 11 Jahren; wie ging es aber zu
daß ich es doch nicht glauben wollte?"

Ludwig XVI. bei seiner Verhaftung am 22. Juni 1791 in Varennes.
Vergl. Joh. Robison „Ueber Geheime Gesellschaften und deren Ge-
fährlichkeit für Staat und Religion", deutsche Übersetzung nach der
3. englischen Auflage. Königslutter bei P. Culemann 1800. 242. Seite.

Herausgegeben

im Auftrage des Verbandes gegen
Überhebung des Judentums E. V.

von

Gottfried zur Beek

7. Auflage

Verlag „Auf Vorposten" in Charlottenburg 4

1922

Anti-Catholicism

In order to comprehend the anti-Catholic sentiment in England during the seventeenth century, it is necessary to understand its causes. In the previous century, Henry VIII (1491–1547) had ceded from Roman Catholic authority by declaring himself the head of the Church in England, and no longer answerable to the Pope. The Reformation continued in earnest with the accession to the throne of his son Edward VI (1537–53), who created the

Below: The Bull of Pope Clement VII against Henry VIII's divorce, 1530; it was as a result of the Pope's refusal to grant Henry a divorce that he broke away from the Catholic Church, setting in motion centuries of conflict between Catholics and Protestants.
Left: The Armada was launched in 1588 by the Spanish king Philip II with the aim of making an armed landing in England, thus returning the country to Catholicism.

Church of England as an Anglican and Protestant body. Following his death, his half-sister Mary I (1516–58) succeeded him and returned the country to Papal authority, cementing this tie by marrying King Philip II of Spain (1527–98), a strong advocate of the Catholic faith. After a reign that lasted only five years, she was succeeded by her half-sister Elizabeth I (1533–1603), an ardent Protestant.

It was during Elizabeth's reign that a number of Catholic rebellions took place that would have seen her assassinated and replaced by her cousin, the Catholic Mary Queen of Scots (1542–87). The final showdown was in 1588 with the launching of the Spanish Armada against the English, which failed in its attempt to restore Catholicism. From that point, Catholicism was seen as a foreign invader intent on subduing England under Papal rule.

In 1605, this fear and loathing of Catholicism manifested itself in the Gunpowder Plot, when leading Catholics plotted to kill the English Protestant king, James I (1566–1625), who in the previous year had commissioned the publication of an authorized version of the Bible in English, anathema to Catholics, who considered the act as one of heresy. The subsequent hard line against Catholicism and the persecution of its adherents continued for over 200 years in England.

The Great Fire of London

In early September 1666, a fire started in a bakery in London during the early hours of a Sunday morning. The fire spread rapidly and destroyed most of London, which at that time was confined to the walled city of about one square mile in size. The conditions were perfect, as it had been a long, dry summer and the closely grouped wooden buildings and thatch were bone dry. The fire was exacerbated by the strong winds that fanned the

Right: The Gunpowder Plot was a 1605 Catholic conspiracy to topple the Protestant monarchy; pictured are the seven principal conspirators, including Guy Fawkes (third from right) and Robert Catesby (second from right).

H G

T

Copied from a rare Print published a

THE Portraits of the Seven Traitors who l:
foundations by gunpowder, with the greate
whole Kingdom, as well Ecclesiastics as La
spectators.—*Robert Catesby, Esq.* (▲), was the
in this affair; he constructed a cellar under
placed on the Parliament House. *Thomas*
those parts of Belgium subject to Duke Al
sworn secrecy with the others on the Gospel
Wrigt (F); *Robert Winter* (G). To whom is

F E B D A C

PRINCIPAL CONSPIRATORS.

time (A.D. 1605). *Under which is an explanation in Latin, translated as follows* :—

red in the vaults of the Parliament House of Westminster near London, to overturn it from its
rt of Westminster; and in it not only to destroy the King, but also the principal Noblemen of the
n, the most powerful Noblemen, and the chief Ministers of the Kingdom, with many thousands of
t author of this horrid conspiracy. *Thomas Percy* (B), of a noble family, was marvellously vehement
Parliament House, and was very diligent in perfecting the mines: his head is now to be seen
ter (C), was invited to, and drawn into this crime by R. Catesby. *Guido Fawkes* (D) who was in
was impelled into this crime by Thomas Winter, and on coming into England, when he had
ceived from a Priest the sacrament called the Eucharist. *John Wrigt* (E), a nobleman; *Christopher*
d R. Catesby's servant, *Bates* (H).

flames and allowed them to spread quickly. Rumours spread that foreigners had started the blaze, and residents quickly formed lynching parties to execute immigrants thought to be responsible.

The King's own Coldstream Guard was responsible for rounding up foreigners and Catholics as part of the investigation. One such detainee was the French-born watchmaker Robert Hubert (1640–66), who confessed to starting the fire and was hanged at Tyburn. In early 1668, Charles II (1630–85) commissioned the building of a monument to the Great Fire close to the site of the fire's origins. One of the plaques on the monument blamed 'the treachery and malice of the Popish faction', which was not removed until the Emancipation of Catholics Act in 1829.

The Popish Plot

In the aftermath of the Great Fire, anti-Catholic fervour increased in England, fuelled in part by Charles II, who had married Catherine of Braganza (1638–1705), a Catholic Portuguese princess; and his brother James, Duke of York (1633–1701), who was openly embracing Catholicism. Their mother Henrietta Maria of France (1609–69) was also a Catholic. To make matters worse, the King issued the Royal Declaration of Indulgence in 1672, suspending all penal laws against Anglican dissenters. Fears were growing among the Protestant majority of a Popish plot to replace the established Anglican Church and return England once again to Catholicism. Titus Oates (1649–1705), a Protestant minister's son, hatched the fictive Popish Plot in 1678, in which he alleged that he knew of plans by Jesuit plotters to assassinate the King. Oates and his associates were interrogated at great length, which led to the conviction and execution of at least 22 Jesuits. Although the King and his Privy Council were initially lukewarm to the allegations, the Popish Plot gained credibility when a leading Protestant and

Left: An old engraving depicting the Great Fire of London in 1666, which destroyed most of the city, including St Paul's Cathedral. Many believed at the time it was an arson attack by Catholics.

Member of Parliament, Sir Edmund Berry Godfrey (1621–78), was brutally murdered on the streets of London.

The murder was never solved, but in the immediate aftermath, anti-Catholic sentiment reached fever pitch, which continued for the next three years. In this time, several high-ranking lords with Catholic leanings were also arrested and tried, but all were acquitted. With several other high-profile denials and acquittals, belief in the Popish Plot waned and eventually Oates was arrested, tried and convicted of perjury, spending the next three years in prison, where he was subjected to brutal treatment.

Above: *The Popish Plot was a fictitious Catholic conspiracy created by Titus Oates, who alleged he knew of plans to assassinate Charles II; many innocent lives were lost as a result of Oates's perjury, for which he was later imprisoned.*
Right: *Anti-Catholic sentiment continued in England until Catholic emancipation in 1829. The Gordon Riots of 1780 in which a mob of 50,000 protestors set fire to buildings in London was the most extreme example.*

The Two Babylons

The Scottish Presbyterian theologian Alexander Hislop (1807–65) issued a pamphlet in 1853, called *The Two Babylons*, alleging that the Catholic Church was merely a continuity of the pagan religion as practised in the ancient city of Babylon, approximately 4,500 years ago, by Nimrod and his mother Semiramis. Nimrod is depicted in the Bible as one who was 'rebellious to God'. The pamphlet suggests that Christian holidays such as Christmas and Easter have origins in Babylonian paganism, and that there was a conspiracy to transfer Babylonian rituals through other ancient religions, a succession that was adopted by the Catholic Church in the first century AD. As an example, Hislop suggested that Easter was in fact taken from the Assyrian 'Ishtar', the name of their fertility goddess.

One of the core tenets of the Catholic Church is the veneration of the Virgin Mary and Her son Jesus. Hislop argued that the whole notion of that veneration began when Nimrod married his mother, was subsequently killed and then worshipped as a god. Semiramis then proclaimed herself to be a virgin, so that both she and Nimrod would be deified. After the fall of Babylon, the cult of mother and child was transferred to Egypt, where the goddess Isis 'immaculately conceived' her son Horus (born on 25 December) and they were both worshipped; while in Greco-Roman religions, the god Attis was also born from an 'immaculate conception' to his mother Nana. In some of these ancient myths and legends there are also various references to death and resurrection.

Most of Hislop's narrative has been discredited as historically inaccurate, but several groups such as the Jehovah's Witnesses have used the text in the promulgation of their own faith. Leading conspiracy theorist David Icke uses the term Babylonian Brotherhood to describe the 'Global Elite' and their aspirations towards a New World Order.

Left: According to Alexander Hislop, the Catholic faith is merely a continuation of an ancient pagan religion, a cult of mother and child, as practised by Semiramis, the Assyrian queen (depicted here), and her son Nimrod, in the city of Babylon.

Jesus and Mary Magdalene

In 2014, a new book was published called *The Lost Gospel*, after its authors re-examined a sixth-century text at the British Library in London. They suggested that the original text known as the *Joseph and Asenath* narrative was in fact a coded reference to the relationship and marriage of Jesus and Mary Magdalene. The book also reveals that they had children, establishing Jesus's bloodline.

Much of the speculation about Jesus's relationship with Mary had already been explored in several stories, the most prominent being the best-selling book *The Da Vinci Code*. In this work, author Dan Brown suggests that the truth about Mary Magdalene has been suppressed for 2,000 years, because the Catholic Church was concerned about the notion of the 'Sacred Feminine' and the primacy of St Peter as the chief apostle, both of which would be undermined. He also suggests that the Church was responsible for portraying Mary Magdalene as a prostitute by conflating her with Mary the sinner, whom Jesus purged of the Seven Deadly Sins. Brown also suggests that the Knights Templar concealed the evidence of the bloodline after discovering important and revealing documents in Jerusalem.

Right: This fourteenth-century painting depicts Mary Magdalene washing the feet of Jesus in atonement for her sins. Some theorists believe their relationship extended to them having a child together.
Below: The Da Vinci Code by Dan Brown caused a sensation with its publication in 2003.

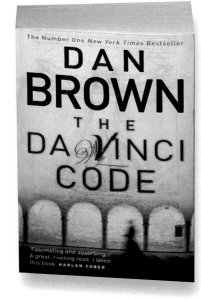

Vanishing Time

There are two aspects of time: that which can be measured, and that which is unquantifiable and indefinite. The measurement of time is straightforward and uses man-made tools such as a clock or a calendar. This makes it possible to manipulate intervals of time, as exemplified by the Phantom Time hypothesis. The other aspect of time is that according to Einstein's Special Theory of Relativity, it is possible for time to slow down when travelling at the speed of light. Some theorists believe that the Bermuda Triangle is one location where it is possible to travel across the fourth dimension of time.

Phantom Time Hypothesis

The German writer and historical revisionist Helibert Illig (b. 1947) proposed the Phantom Time Hypothesis in 1991. The theory is that we are currently living in the eighteenth rather than the twenty-first century. He arrived at this conclusion when examining the changes to the calendar made by Pope Gregory XIII (1502–85) in 1582. Up until this time, the Julian calendar was in operation, established by Julius Caesar in 45 BC and derived using lunar periods. The Gregorian calendar was then introduced, which had a small difference of approximately 11 minutes per year. Gregory's scholars therefore accumulated the lost days (10 by their reckoning), and adjusted the new calendar accordingly.

Illig, however, recalculated the figures and suggested that Gregory and his accomplices deliberately faked the figures, calculating them to the

Left: The Coronation of Emperor Charlemagne in Rome, 800; the purpose of the new Gregorian calendar, so Illig claims, was to rewrite history by fabricating Emperor Charlemagne and his entire line.

year 1282, instead of 1582, thus losing 300 years of history. It is further suggested that these lost years occurred between 610 and 910 AD, when very little history is written down and cannot easily be verified. The hypothesis also suggests that there was a conspiracy between the Holy Roman Emperor Otto III (980–1002) and Pope Sylvester II (946–1003) to fabricate the first Holy Roman Emperor, Charlemagne (742–814), and his Carolingian dynastic line, to position themselves at the dawn of the new Christian Millennium.

The Bermuda Triangle

The Bermuda Triangle is a large, roughly triangular area in the Atlantic Ocean, covering some 500,000 square miles (1.3 million square km), stretching between the south-east coast of Florida, the island of Bermuda and Puerto Rico. This area of sea has always been notorious amongst sailors, but it was not until the twentieth century that it gained its reputation as a place of intrigue, where ships and planes could vanish, seemingly into thin air. While most scientific investigations have concluded that the disappearances are due to unusual wind and tidal currents, there are a plethora of theories that provide alternative conclusions.

Probably the most common of these is that aliens use the Triangle to abduct humans. This theory is based on the unusual disappearance of a military aircraft, Flight 19, in December 1945. Partway through an otherwise mundane training exercise, the pilot radioed a distress call that his navigational equipment was not functioning and that he was lost: no more was heard from the aircraft, which then vanished without trace. In 1950, the first of many reports was published, noting the numerous unexplained disappearances there had been in this area. It was not until 1964 that the myth of the Bermuda Triangle really took hold, when writer Vincent Gaddis

Right: The Bermuda Triangle area had a sinister reputation even before the 'Triangle' myth; wrecks were thought to end up in the Sargasso Sea.

AZORERNA

EUROPA

1UDAS

KANARIE-
ÖARNA

AFRIKA

KAPVERDE-
ÖARNA

KA

speculated that the plane and its crew were victims of supernatural forces, possibly even extraterrestrials.

Others have theorized that a meteorite crashed into the sea 10,000 years ago and its magnetic energy is still interfering with navigational equipment. Some suggest that the lost city of Atlantis sits on the ocean floor beneath the Triangle, emitting some form of energy force from a huge pyramidal crystal that creates the unusual tidal currents and winds. Perhaps the most far-fetched theory is that the Triangle facilitates a time warp that allows movement across the fourth dimension of time.

Although scientists have, over the years, presented plausible explanations as to the cause of the disappearances – freak weather, methane gas surges, underwater earthquakes, – it seems that this apprently empty stretch of water has gained a place in the collective imagination as a source of mystery and fascination, and theorists are not prepared to give up on this notion just yet.

Above: *An aerial view of the area of the so-called Bermuda Triangle.*
Left: *References to the Bermuda Triangle were not made until 1950, when scientists began to explore losses of ships and aircraft in the region, most notably Flight 19 in 1945, the squadron of which are pictured here.*

Deaths, Disappearances & Deceptions

Assassinated?

Although John F. Kennedy is probably the best known, four US presidents have been assassinated while in office, all as the result of gunshot wounds. In addition, there have been attempts to assassinate every US president since Kennedy, with the exception of his successor Lyndon B. Johnson (1908–73). Assassinations are, of course, not unique to the US, and neither do they have to be heads of state. Read on to find out more about the mysterious circumstances surrounding some of the world's most notorious assassinations.

The Romanovs

The Romanovs were the ruling Imperial family of Russia at the time of the October Revolution in 1917 and comprised Emperor Nicholas II (1868–1918), his wife and five children. When the Bolsheviks came to power in 1917, the family was taken into protective custody by the provisional government. They remained in custody until 1918, when they were summarily executed by firing squad at the behest of the Bolsheviks under their leader Lenin (1870–1924).

There was speculation that they had not been killed but had gone into hiding, but in 1979 the remains of the emperor, empress and three of their children were discovered by amateur historians, who kept their findings secret from the authorities. The gruesome discovery was not confirmed until after the fall of the Soviet Union, when the identities of the bodies were confirmed by DNA testing in 1992. The remains of the other two children were not discovered until 2007, and their bodies have yet to be reinterred. Books have been written and films made about the possible escape of one of the children, Anastasia. Numerous imposters claiming to be her emerged, but their claims have since been disproved. But could the authorities' failure to reinter the remaining bodies indicate some truth in the story?

Previous page: Marilyn Monroe's body is removed to the morgue on a stretcher by a police officer.
Left: The Romanov family, 1914: the emperor and empress and their children Anastasia, Olga, Tatiana, Marie and Alexei.

JFK

The assassination of President John F. Kennedy (1917–63) on 22 November 1963 in Dallas, Texas, USA, is probably the most debated conspiracy theory of all time. Essentially, the theories revolve around three key questions: why was he killed, by whom and how? The succeeding president Lyndon B. Johnson (1908–73) signed an executive order a week after the assassination to answer these questions. The Warren Commission was established and took nine months to produce its report. It found that the main suspect, Lee Harvey Oswald (1939–63), who had been arrested on the same day as the assassination, was solely responsible for Kennedy's death.

According to the commission, the shots had been fired from the upper storey of the Texas School Book Depository, using a bolt-action rifle, found at the scene. Kennedy had died as a result of being hit by two bullets, one that entered the rear of his neck and exited through the front, and a second that hit him in the head, which was deemed to be the fatal shot. In addition, the Governor of Texas, John Connally (1917–93), who was sitting immediately in front of Kennedy, was also hit, sustaining injuries to his back, chest, wrist and thigh. The commission found that the first bullet to hit Kennedy and travel through his neck was the same bullet that then continued its trajectory, hitting Connally. Connally, for one, was very sceptical about the commission's findings, along with many others who believe that a single bullet, sometimes mockingly referred to as the 'magic bullet', could not have inflicted such damage because of the trajectory. This leads to the possibility, as far as conspiracy theorists are concerned, of a second gunman, possibly stationed at another upper storey of the same depository.

The fatal shot, however, is the one that is most hotly debated. At the time of the assassination, Ukranian-American Abraham Zapruder (1905–70) was

Right: John F. Kennedy and his wife, Jacqueline Kennedy, ride up Broadway, New York in a ticker-tape parade.
Right small: Bystanders look on as Jacqueline Kennedy reaches over to help her husband, who lies on the rear of a car after being struck by the assassin's bullet as his motorcade travelled through Dealey Plaza in Dallas, Texas.

JFK SHOT TO CONNALLY WO

Hidden Assassin Used Rifle

DALLAS (AP)--President John F. Kennedy, 36th President of the United States, was shot to death today by a hidden assassin armed with a high-powered rifle.

Kennedy, 46, lived less than an hour after a sniper cut him down as his limousine left downtown Dallas.

Automatically, the mantle of the presidency fell to Vice President Johnson, a native Texan who had been riding two cars behind the chief executive.

Asst. Presidential Press Secretary Kilduff said Johnson was not hit. He previously had been reported wounded.

There was no immediate word on when Johnson would take the oath of office.

Kennedy died at Parkland Hospital, where his bullet-pierced body had been taken in

his eyes red-rimmed, Yarborough said:

"I could see a Secret Service man in the President's car leaning on the car with his hands in anger, anguish and despair. I knew then something tragic had happened."

Yarborough counted three rifle shots as the presidential limousine left downtown Dallas through a triple underpass. The shots were fired from above—possibly from one of the brid

to be serious. But doctors said that Connally had a good pulse and that his respiration was satisfactory.

Connally also was hit in the right wrist.

Though Mrs. Kennedy cried, "Oh, No" in horror and despair after her husband was shot, she did not collapse in or give way to hysteria.

When she entered the hospital, her clothing was covered with blood from her husband's wounds.

In Washington, Atty. Gen. Robert F. Kennedy, the President's younger brother and clos-

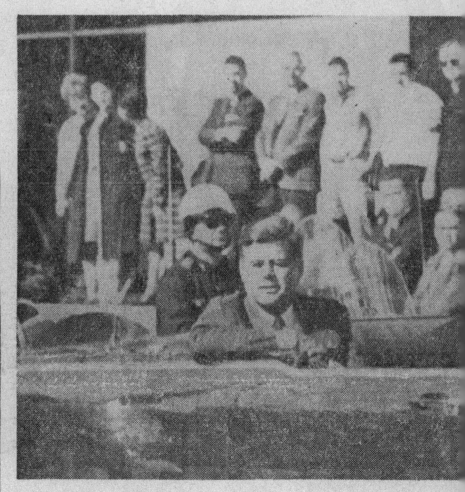

JUST BEFORE SHOOTING—President Kennedy and Gov. Connally are shown just before Kennedy was assassinated in Dallas Friday. A sniper fired at the

motorca
emergen
apparent

DEATH!
UNDED

Connally Denies 'Real' Rift

FORT WORTH (UPI) — Gov. Connally denied today there was any significant rift in the Democratic party in Texas, but said, "If the presidential election were held today it would be a very close contest."

Asked about Sen. Yarborough's charge in San Antonio that he was "uneducated governmentally," Connally said, "We have made every effort we know how to provide a Texas welcome in five cities the Kennedys have visited and will visit."

A SIDESTEP

The governor sidestepped a question on whether he will support Yarborough in the Democratic primary next year. Connally and Yarborough are political enemies.

"I am going to be looking out for John Connally," the governor said. "I am not going to interfere in any other race. That

both men were hit. They were given ment in a Dallas hospital. Connally shot in the back.

filming the motorcade on a home cine camera, which has been subsequently used in a frame-by-frame analysis of the killing. The fatal shot to Kennedy's head appears to show the President being hit and then being thrown backwards by the impact, leading many to suggest that there was another hidden assassin in front of the motorcade, on an embankment known as the 'grassy knoll'. The Zapruder film has been the subject of the main conspiracy that Oswald did not act alone as the Warren Commission stated, and that the authorities were actually covering it up.

Because Oswald was murdered, only two days after being arrested, by a lone gunman, known to the authorities as a Mafia enforcer, we will probably never know if he acted alone or not. Both the Mafia and the CIA are thought to be involved in Kennedy's assassination by different conspiracy theorists and for different reasons.

Above: *John F. Kennedy, 35th President of the United States.*
Left: *The* San Antonio Light *reports the assassination of President Kennedy, 23 November 1963.*

Diana, Princess of Wales

On 31 August 1997, the United Kingdom and much of the rest of the world was shocked by the sudden and tragic death of Diana, Princess of Wales (1961–97), in a car crash in Paris. A huge outpouring of grief followed, with people understandably wanting answers as to how such a tragedy had happened.

The Princess had, a year before, been divorced from her husband Charles, the Prince of Wales (b. 1948) after many years of unhappiness, during which time the press had hounded her, wanting to know every salacious detail of their relationships outside of the marriage. Diana herself had warned in a letter to her butler in 1993 that 'my husband is planning an accident in my car', and some of her closest friends have stated that she believed her life was in danger.

At the time of the tragedy, Diana was in a relationship with Dodi El-Fayed (1955–97), the son of a wealthy businessman. Diana and Dodi, along with the driver of the Mercedes car, Henri Paul (1956–97), were all killed in the crash. The subsequent French investigation concluded that it was an accident caused by the vehicle being driven too fast, while the much later British inquest returned a verdict of 'unlawful killing' by the driver, due to him being intoxicated and

Right: Princess Diana sitting on the steps of her home at Highgrove, Gloucestershire
Below: The wreck of the Mercedes-Benz in which Diana, Princess of Wales, was killed in August 1997, in the Pont de l'Alma road tunnel in Paris.

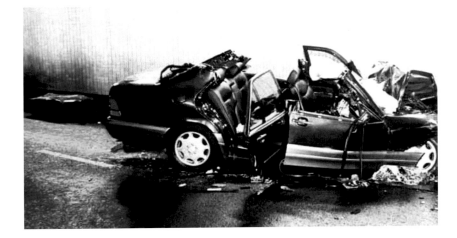

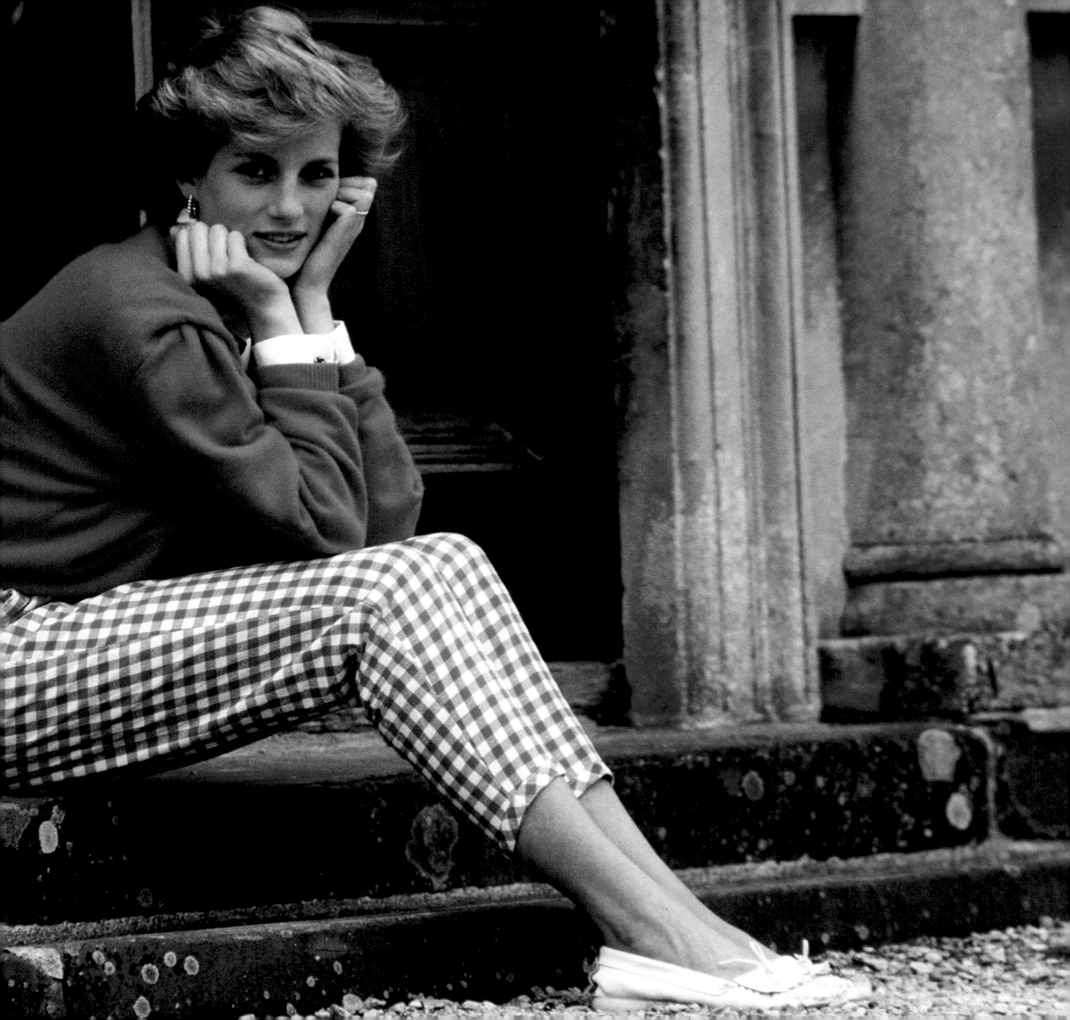

driving recklessly. Dodi's father Mohamed Al-Fayed (b. 1929) maintained, however, that the pair were murdered as part of a conspiracy involving the Royal Family and the British intelligence service MI6, which led to the much later inquest by the British judiciary; an enquiry that took six months and found no evidence of the culpability of the intelligence services or the Royal Family.

The journalist Noel Botham (1940–2012) was sceptical about the French and British findings. According to his book *The Murder of Princess Diana* (2007), agents of the 'military-industrial complex' (*see* page 100) conspired to kill Diana, following her high-profile campaign to ban the worldwide use of anti-personnel land mines, and the resultant loss of profits by arms manufacturers. There are certainly enough questions about Diana's death that remain unanswered to fuel a number of conspiracy theories and that will probably remain unresolved.

General Wadyslaw Sikorski

General Sikorski (1881–1943) was the military commander and political leader of Poland during the Second World War. While in exile, he continued to command his forces stationed overseas, and in May 1943 visited them in the Middle East. On the return flight from Gibraltar the aircraft in which he was travelling crashed into the sea immediately after take-off, killing him, his daughter and his Chief of Staff. A subsequent British enquiry was unable to find a cause for the crash, but concluded that it had not been sabotaged. The Polish authorities questioned why the British had ruled out sabotage, and the Nazis, seeing this as a propaganda opportunity, suggested that it was a British-Soviet conspiracy, since the two countries were now allies. In another twist, it has been suggested that the perpetrators of the crash were those in Polish high command who were opposed to the idea, supported by Sikorski, of renewing the Polish-Soviet peace agreement signed in Riga in 1921, which gave Poland substantial areas of Belarus and Ukraine.

Left: General Sikorski, the Prime Minister of the Polish Government in Exile, salutes Polish units of the Royal Air Force stationed in Britain during the Second World War.

Dr David Kelly

In February 2007, the BBC aired one of its 'Conspiracy Files' documentaries about the death of Dr David Kelly (1944–2003), a leading scientist and government advisor on biological warfare. In July 2003, his body was found close to his home in some woods, after he was reported missing by his wife. Kelly was an authority on biological and chemical weapons for the United Nations and had been involved in intelligence work on behalf of the British government, trying to establish whether Iraq had weapons of mass destruction (WMDs). Prior to the invasion of Iraq in March 2003, the British Prime Minister Tony Blair (b. 1953) had advised Parliament that Iraq had WMDs and could make them operational in '45 minutes', a statement intended to hasten immediate action. The intelligence material Blair used is referred to as the 'September Dossier'. Following the invasion of Iraq between March and May 2003, no WMDs were found and in July a BBC journalist Andrew Gilligan (b. 1968) announced that the British government had 'sexed up' the September Dossier to justify the invasion.

It subsequently emerged that the information had come from Kelly, who confided in Gilligan that the '45 minutes' was not an accurate reporting of the evidence. As a result, the Foreign Affairs Select Committee interrogated Kelly in Parliament, a televised event in which the normally composed scientist appeared to be very unsettled. Two days later he was found dead. The subsequent enquiry commissioned by the Prime Minister and chaired by Lord Hutton (b. 1931), a senior judge, returned a verdict of suicide. Usually, a coroner, who has full legal powers, investigates the suspicious death of one person, so that witnesses can be summonsed to give evidence under oath. The same is not true of an enquiry. Certain key witnesses did not give evidence to the enquiry, leading to accusations of a government cover-up. Conspiracy theorists believe that Kelly was 'silenced'.

Right: The Hutton Report, published in January 2004, aimed to examine the circumstances surrounding Sir David Kelly's death; it has since been branded a 'whitewash' and a government cover-up.

Did They Really Die?

For the last three quarters of a century, mystery has surrounded the death of the Nazi war leader Adolf Hitler, since there were few verifiable witnesses to the body's disposal following his alleged suicide. The same can be said of the terrorist leader Osama bin Laden, who was killed by American soldiers and then buried at sea, with few witnesses actually seeing his dead body. Mystery also surrounds the deaths of two of the most famous singers of the twentieth century, Elvis Presley and Paul McCartney. Numerous sightings of Presley have been made, despite his 'body' being seen by thousands prior to his funeral; while McCartney is alleged to have been killed in a car crash in 1967, and the person we all believe to be Paul McCartney is in fact a lookalike.

Adolf Hitler

Following the unconditional surrender of Nazi Germany in May 1945, one of the unresolved questions of the time was 'Is Hitler dead?' Adolf

Left: Hitler reportedly killed himself in his 'Führerbunker' in Berlin, which was later partially destroyed.
Below: We can be certain of the fate of Adolf Hitler's deputy Rudolph Hess, shown on the left of this picture, but not everyone is convinced that the Führer committed suicide.

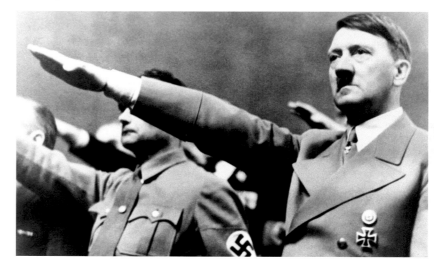

Hitler had been the Führer of Germany since 1934 and had led his country into the Second World War. His last-known sightings were at his so-called Führerbunker in Berlin. The Soviets were the first occupying force to enter this part of Berlin and are known to have actively promoted disinformation about Hitler's death. Even at the Potsdam conference in July 1945, the Soviet leader Josef Stalin (1878–1953), when asked if Hitler was dead, replied emphatically, 'No'.

It is generally understood that, according to captured staff from the bunker, Hitler poisoned his wife and shot himself, before their bodies were burnt in the garden outside of the bunker. However, many conspiracy theorists believe he escaped Germany and found his way to Argentina and the sanctuary of its president Juan Perón (1895–1974). In a recent documentary series for The History Channel called 'Hunting Hitler', it was argued that the Führer and others escaped Germany by U-boat to Argentina. The evidence came from now-declassified documents from the FBI, CIA and MI6, as well as German, Russian and Argentinian documents.

Above: Winston Churchill sits in Adolf Hitler's chair outside the Führer's destroyed air raid shelter, Berlin, Germany, 1940s.
Right: The US military newspaper Stars and Stripes announces Hitler's death, 30 April 1945, after the collapse of the Third Reich; or did he escape into exile, as some claim?

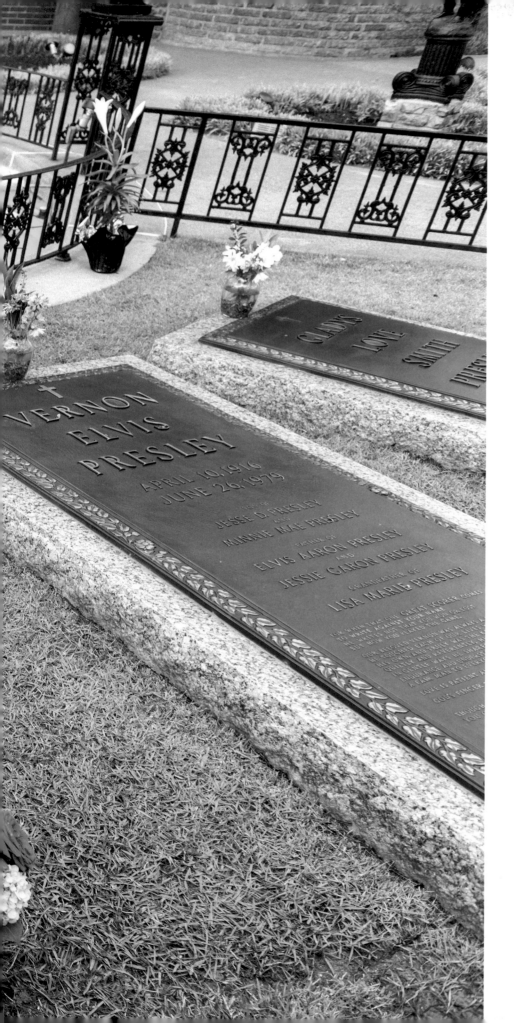

Elvis

There have been several books and documentaries made suggesting that Elvis Presley (1935–77) may have faked his death on 16 August 1977. As with most conspiracies of this kind, it is often very difficult for fans to come to terms with the death of a popular icon; psychologists suggest that this leads many people to genuinely believe they have seen Elvis and to be convinced that he is alive. There have been and continue to be numerous sightings of Elvis, some of which are more credible than others. According to the medical examiner, Elvis died from cardiac arrhythmia. However, such a diagnosis can normally only be made on someone who is alive.

Presley's own doctor was suspected of over-prescribing drugs and the general consensus was that the singer died from polypharmacy, resulting in the doctor's revocation of his medical licence. A later enquiry into the singer's death in 1994 confirmed the diagnosis of polypharmacy, and that this may have contributed to constipation, and a resultant heart attack while using the toilet. The official verdict is that Elvis died from a heart attack, while in

Above: Elvis is dead!
Left: Elvis Presley and family gravestones in the 'Meditation Garden' at Graceland, home of the late Elvis Presley in Memphis, Tennessee.

his bathroom. Apart from the 'sightings', many conspiracy theorists believe Elvis faked his own death because of depression and the need to escape the continuous adoration of his fans, a pressure he could no longer deal with.

Paul McCartney

In the February 1967 edition of the fanzine *The Beatles Monthly Book*, the editors sought to quell a rumour that Paul McCartney (b. 1942) had died in a car crash the previous month. This was successful until an American DJ, Russ Gibb (b. 1931), began investigating the possibility that he was in fact dead. A number of people had called his radio station to tell him of various clues in subsequent tracks recorded by the Beatles referring to his death. In October 1969, Gibb aired a two-hour radio program on the subject, creating what became known as the 'Paul is Dead' theory, including his replacement by a lookalike. Subscribers to this theory use the 'clues' in the Beatles records to suggest that the other three members of the group covered up McCartney's death for fear of losing revenue, or that it was their way of breaking the news in a subtler manner.

Above: The revenue derived from Elvis Presley Enterprises, a trust set up to manage the estate after his death, has far outstripped his earnings while he was alive. Did he fake his own death?
Right: The Beatles in London, 1967 (left to right): Paul McCartney (real or imposter?), George Harrison, Ringo Starr and John Lennon.

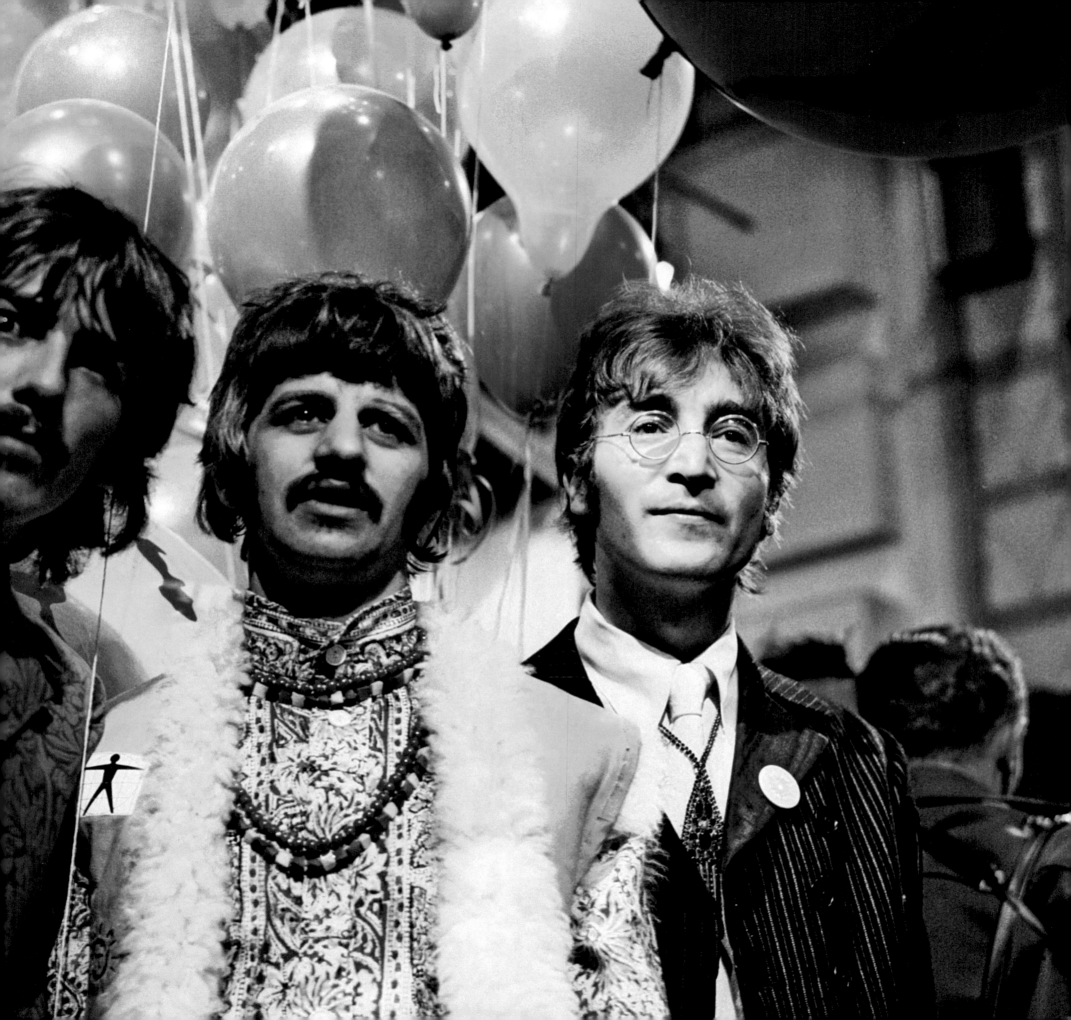

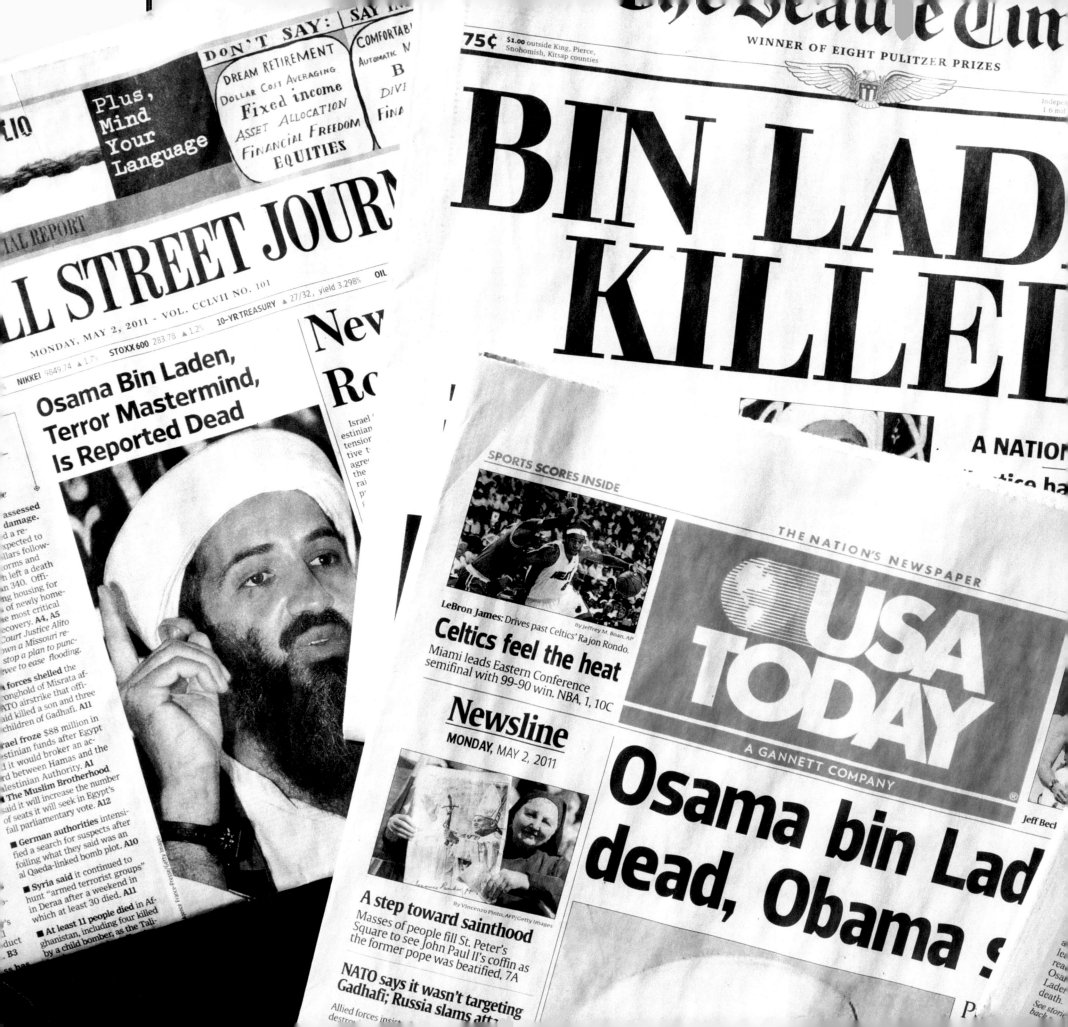

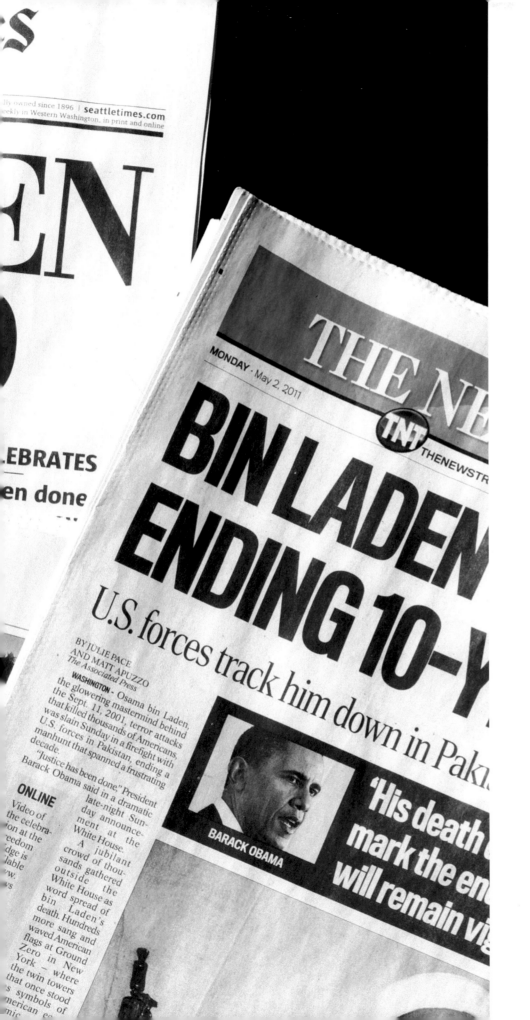

Osama bin Laden

In the aftermath of the 9/11 attacks, Osama bin Laden (1957–2011), the leader of Al-Qaeda, became America's most wanted man, with a $25-million bounty on his head. He was finally tracked down to a private dwelling in Pakistan and assassinated on the orders of President Obama, by Navy SEALS. His dead body was taken to Afghanistan for identification and then taken on board an American naval ship out to sea for burial.

The absence of an imam on board and the secrecy surrounding the body's disposal have led conspiracy theorists to ask: 'Is bin Laden dead?' Did he die on 1 May 2011 as alleged, as a result of bullet wounds, or was he already dead and the US needed to prove his demise? Were the Pakistani authorities complicit in the assassination, despite President Obama stating it was a US covert mission? According to investigative journalist Seymour Hersh (b. 1937), the US account of bin Laden's death was false and he accused the American press of being obsequious to the president. He further claims that the Pakistani secret service, the ISI, were complicit in bin Laden's death.

Below: Pakistani police and media gather outside the burnt hideout of Al-Qaeda leader Osama bin Laden following his death by US Special Forces in a ground operation in May 2011.
Left: The death of Osama bin Laden was widely reported in the press, but President Obama refused to release photographs of the dead man, leading some to ask if he was really dead.

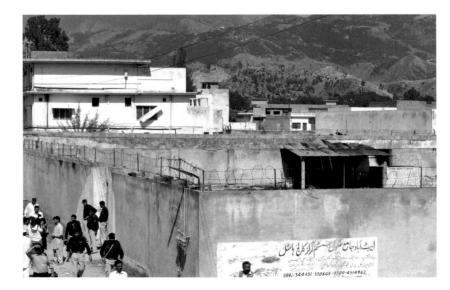

Conspiracy Theories: Deaths, Disappearances & Deceptions

Mysterious Deaths

The sudden death of a popular icon is a terrible shock to most people at the time of it happening and affects people in different ways. Many look for explanations and causes, which often leads to conspiracy theories. The popular film star Marilyn Monroe died very suddenly from a drug overdose, but was it self-inflicted or was she murdered? The hip-hop star Tupac Shakur was gunned down on the streets of Los Angeles. Clearly it was murder, but by whom? Was it a hit by rival rappers from New York, or someone with altogether more sinister motives, with connections to the Illuminati?

The Curse of the Pharaohs

In 1922, a British expedition, led by the archaeologist Howard Carter (1874–1939) and funded by archaeologist and 5th Earl, Lord Carnarvon George Herbert (1866–1923), discovered the tomb of the Pharaoh Tutankhamun in the Valley of the Kings in Egypt. Despite warnings of an ancient curse on anyone who disturbed the tomb of a pharaoh, Carter's team, including Carnarvon, entered the burial chamber on 29 November 1922. On the same day, a cobra, the symbol of Egyptian pharaohs, is alleged to have eaten Carter's pet canary. Four months later, Carnarvon died from blood poisoning as a result of an infected mosquito bite on his cheek. Carter lived until 1939, but many others connected to the expedition, as well as subsequent visitors to the tomb, have died in mysterious circumstances, thus perpetuating a belief in the curse of the pharaohs.

Right: Egyptologist Howard Carter (right) with Lord Carnarvon at the Valley of the Kings excavation site, Egypt, in 1922; Carnarvon was to die later that year from the supposed Curse of the Pharaohs.
Next page: Howard Carter and Lord Carnarvon in the Tomb of Tutankhamun, 1922; did they inadvertently unleash an ancient curse?

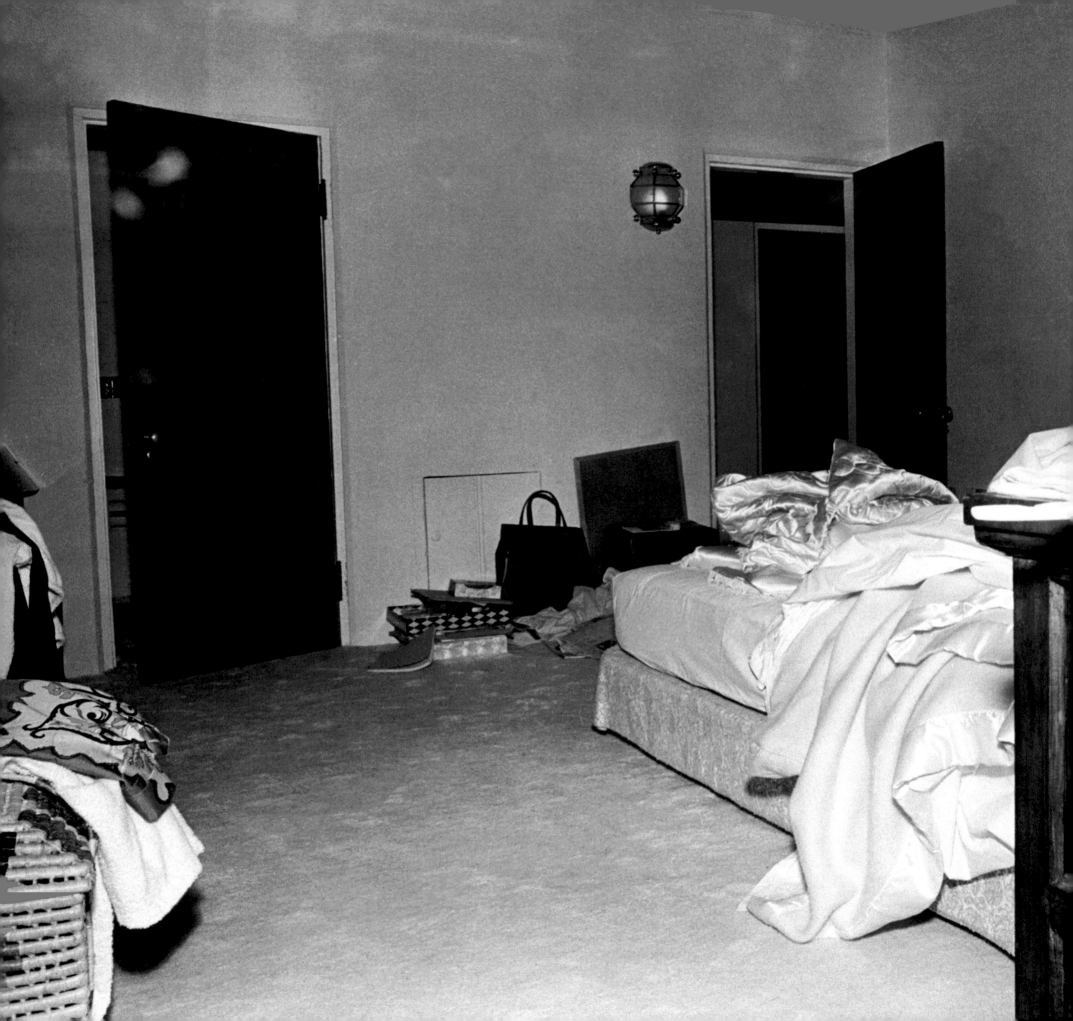

Marilyn Monroe

Norma Jean Baker (1926–62), known to millions of her fans as the film star Marilyn Monroe, died of a barbiturates overdose on 5 August 1962. The official verdict was 'probable suicide', which led many conspiracy theorists to question how and why she died. Was she murdered? Was the suicide accidental or deliberate?

The three-times-married film star was known to be in a poor state of mental health at the time, and was addicted to drugs and alcohol in an effort to stave off depression. There was no suicide note and the coroner ruled out an accidental overdose as, according to the autopsy, ingestion took place in gulps of tablets at a time. The cause of death was likely therefore to have been a deliberate suicide. The fact that the coroner recorded a 'probable suicide', however, led some people to wonder if Monroe had in fact been murdered. The first indication of this was with the publication of *Marilyn: The Biography* (1973) by the writer Norman Mailer (1923–2007), in which he speculated that the CIA and/or FBI had murdered her because of her casual sexual affairs with Robert and John F. Kennedy.

Above: Marilyn Monroe in 1953.
Left: Marilyn Monroe was found dead of a barbiturates overdose on 6 August 1962; the verdict of 'probable suicide' has led many to speculate if there was not more to it than this.

Tupac Shakur

Tupac Shakur (1971–96), also known also as 2Pac, was one of the world's most famous hip-hop music artists, even before his tragic and violent death in September 1996 at the age of 25. Following his murder on the streets of Las Vegas, an album entitled *The Don Killuminati: The 7 Day Theory* (1996) was released which, compared to his earlier work, was seen as much darker, with more anger in his voice and in the lyrics. Apparently, while he was in prison the previous year, he learned about the Illuminati and developed a loathing for them and their ambition to oppress society. Was he killed by the Illuminati? The album had a number of insults directed at other contemporary hip-hop artists, such as Christopher Wallace (1972–97), a.k.a. The Notorious B.I.G. from New York, fuelling an intense rivalry between the East and West coast hip-hop scenes. Given that 'Biggie' was also gunned down on the street in a manner similar to the murder of Tupac, was this an act of revenge? Conspiracy theorists are more likely to believe it was the work of the Illuminati.

Above: The hip-hop artist Tupac Shakur was brutally gunned down on the streets of Las Vegas just after recording a controversial album, which insulted some of his rivals in New York.
Right: The Notorious B.I.G. – was his death revenge for that of Shakur?

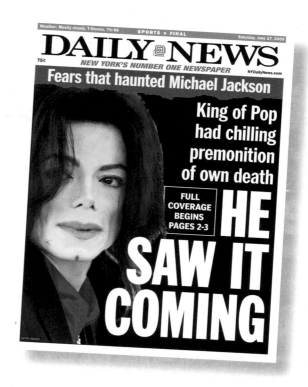

Michael Jackson

Another pop culture idol, Michael Jackson (1958–2009) was known to many as the 'King of Pop'. When he died under suspicious circumstances, the coroner returned a verdict of homicide. He died from an overdose of drugs prescribed to him by his physician Dr Conrad Murray (b. 1953), who was later convicted of manslaughter. Did Murray conspire with others to precipitate Jackson's death? Michael told his sister La Toya (b. 1956) on several occasions that he feared for his life, because of the huge amounts of money his business interests generated. Jackson's daughter Paris (b. 1998) also supports this theory.

As with Elvis, many people believe that Jackson is not dead and suggest there have been sightings of the 'King of Pop'. One of the most mysterious was the arrival of a man known as Alain Pontifex in a lakeside home in Ontario, Canada, shortly after Jackson's supposed death. The complex is heavily guarded, and when questioned, no one is forthcoming about the new resident. Did Jackson fake his own death?

Above: Since he died in 2009, many have claimed Michael Jackson's death was faked so that he (or others?) could benefit from his vast estate.
Left: Michael Jackson performs at the Super Bowl XXVII Halftime show at the Rose Bowl on January 31, 1993 in Pasadena, California.

Missing, Presumed Dead

Aperson is usually presumed officially dead seven years after they are last seen alive, unless there has been some form of verifiable contact from the missing person. An example of this being applied to a high-profile case was that of the union boss Jimmy Hoffa (1913–1982) who was declared dead *in absentia* exactly seven years after his disappearance in 1975. Although this rule applies in most cases, an exception was made to another high-profile missing person, Lord Lucan, who was wanted as the main suspect in a murder, and not officially declared dead for 42 years.

Lord Lucan

Richard John Bingham, the 7th Lord Lucan (1934–?) disappeared in November 1974, and has not been heard of since. At the High Court in London in February 2016 he was officially and legally declared dead, despite no body ever having been found. On the evening of 7 November 1974, his children's nanny, Sandra Rivett (1945–74), was bludgeoned to death at the family home in London, and because of his subsequent disappearance, Lucan became the prime suspect. His wife was also attacked and she identified Lucan as her assailant. The last known and confirmed sighting of Lucan was at a friend's house in Sussex, where he borrowed a car and drove to the port of Newhaven, presumably to take a ferry to the Continent. Lucan had a number of influential contacts and it is assumed they were complicit in his disappearance and concealment.

Right: The flamboyant Lord Lucan, a professional gambler, had amassed large debts at the time of his disappearance and has never been found, despite several sightings around the world.

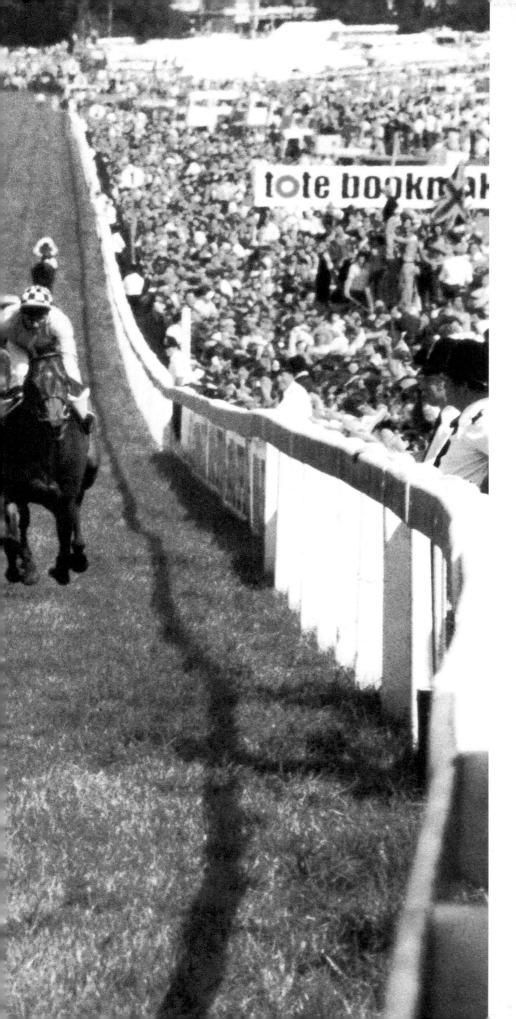

Above: A Garda officer on duty in the grounds of Ballymany Stud, County Kildare, from where Shergar was taken in 1983; but where did he go?

Shergar

The Irish-bred racehorse Shergar won the 1981 Epsom Derby by 10 lengths, a record that remains unbeaten. Two years later, he was stolen from an Irish stud farm by masked gunmen and was never seen again. Within a few days of the abduction, several telephone calls were made demanding a ransom for the horse. The most credible candidate for the theft was the Provisional IRA, seeking funds to purchase arms. A former IRA member turned 'supergrass', who stated that the horse had been shot not long after the abduction, confirmed this. However, his body has never been recovered and the criminals never apprehended.

Left: Shergar, the 10/11 favourite, ridden by Walter Swinburn, en route to winning the Epsom Derby by 10 lengths, the largest margin in the history of the race, on 3 June 1981.

Who Were They?

There are a number of conspiracy theories regarding the actual identities of historical figures. One of the most fiercely debated identities is that of the English dramatist and poet William Shakespeare, who it is argued could not possibly have written the plays and poems attributed to him because of his social background. The Shakespeare Question, as it is referred to, is one of serious academic study. No less serious is the search for the identity of perhaps the world's most infamous serial killer, Jack the Ripper, who brutally murdered at least five women in London during 1888.

William Shakespeare

The William Shakespeare (1564–1616) authorship question began in the nineteenth century, with certain American writers such as Ralph Waldo Emerson (1803–82) trying to reconcile the disparity between Shakespeare's modest origins and the genius of his works. By the nineteenth century, Shakespeare was revered as a genius and the most imaginative writer using the English language. According to his biography, however, he was the son of a glove-maker, with limited access to education. Furthermore, given his lowly status, he would have had limited knowledge of the court life that is such a feature of the plays. This apparent disparity, and the fact we know so very little of Shakespeare's life, led to a number of people questioning the authorship of his plays and poems.

A number of luminaries have expressed scepticism about the authorship, including Mark Twain (1835–1910), Henry James (1843–1913) and Sigmund Freud (1856–1939). A number of 'alternative' writers have been put forward

Right: Edward de Vere, c. 1575; was he the true Shakespeare?
Far right: The frontispiece to the First Folio of William Shakespeare's plays published by two actor friends seven years after the writer's death. Were they complicit in a conspiracy to conceal the author's true identity?

as the 'genuine' authors, including Francis Bacon (1561–1626), Roger Manners, the 5th Earl of Rutland (1576–1612) and Edward de Vere, 17th Earl of Oxford (1550–1604). Another candidate is William Stanley, 6th Earl of Derby (1561–1642), who in some people's eyes is an obvious candidate since he has the same initials as Shakespeare.

Numerous conspiracy theory books have emerged from this discourse, but a more considered opinion is that of the Shakespearean actor and former director of the Globe Theatre in London, Mark Rylance (b. 1960), who states that authorship was different then, and suggests that the writing may well have been a shared project. With another renowned Shakespearean actor, Sir Derek Jacobi (b. 1938), he produced the Declaration of Reasonable Doubt in 2007, to facilitate a more measured discourse among academics.

Jack the Ripper

In the autumn of 1888, five prostitutes were brutally murdered in London's East End, by an unknown killer known as Jack the Ripper. He was never apprehended for these killings that took place over a 10-week period, two of them on the same night. It is recognized as the first serial killing of modern times, and still holds a macabre fascination today, with daily walking tours retracing the Ripper's steps. Since the identity of the Ripper has never been confirmed, a number of conspiracy theories have evolved concerning possible candidates and cover-ups. The most prominent of these was a member of the Royal Family, Prince Albert Duke of Clarence (1864–92), grandson of Queen Victoria, his crimes covered up by the machinations of the government and the Metropolitan Police. This theory and many others, such as those that suggest the writer Lewis Carroll (1832–98) and the artist Walter Sickert (1860–1942) were the Ripper, have now been analysed by 'Ripperologists' and academics and are now largely discredited.

Left: 'The last crime of Jack the Ripper', depicted in newspaper Le Petit Parisien. *Despite many theories – plausible and implausible – his identity has never been discovered.*

Index

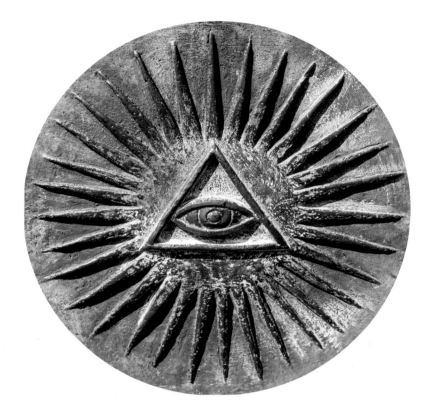

For further illustrated books on a wide range of subjects,

in various formats, please look at our website:

www.flametreepublishing.com